PHOTOSECRETS
BLUE RIDGE PARKWAY VIRGINIA

WHERE TO TAKE PICTURES

BY
ANDREW HUDSON

*"A good photograph
is knowing where to stand."*
— Ansel Adams

📣 Acclaim for PhotoSecrets

🏆 Grand Prize in the National Self-Published Book Awards

🏆 Benjamin Franklin Award for Best First Book

🏆 Best Travel Guide, Benjamin Franklin Awards finalist

"Impressive in its presentation and abundance of material."
— *National Geographic Traveler*

"PhotoSecrets books are an invaluable resource for photographers."
— *Nikon School of Photography*

"One of the best travel photography books we've ever seen."
— *Minolta*

"Guides you to the most visually distinctive places to explore with your camera."
— *Outdoor Photographer*

"This could be one of the most needed travel books ever published!"
— *San Francisco Bay Guardian*

"The most useful travel guides for anyone with a camera."
— *Shutterbug's Outdoor and Nature Photography*

"Takes the guesswork out of shooting."
— *American Way (American Airlines magazine)*

📷 Gallery

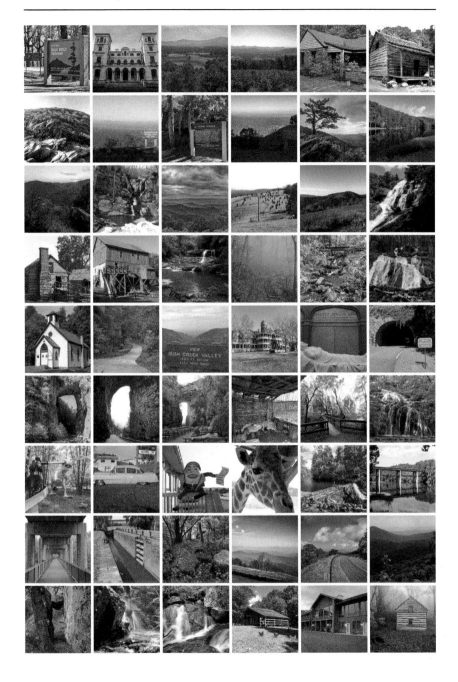

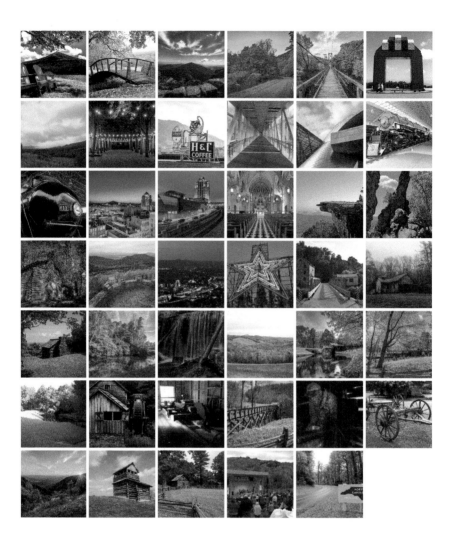

© Copyright

PhotoSecrets Blue Ridge Parkway Virginia, first published January 15, 2019. This version output December 6, 2018.

ISBN: 978-1930495142. Distributed by National Book Network. To order, call 800-462-6420 or email customercare@nbnbooks.com.

Curated, designed, coded and published by Andrew Hudson. Copyright © 2018 Andrew Hudson/PhotoSecrets, Inc. Copyrights for the photos, maps and text are listed in the credits section. PHOTOSECRETS and the camera-map-marker icon are registered trademarks of PhotoSecrets.

> *"'And what is the use of a book,' thought Alice*
> *'without pictures or conversations?'"*
> *— Alice's Adventures in Wonderland, Lewis Carroll*

© Copyright

🔨 Disclaimer

The information provided within this book is for general informational purposes only. Some information may be inadvertently incorrect, or may be incorrect in the source material, or may have changed since publication, this includes GPS coordinates, addresses, descriptions and photo credits. Use with caution. Do not photograph from roads or other dangerous places or when trespassing, even if GPS coordinates and/or maps indicate so; beware of moving vehicles; obey laws. There are no representations about the completeness or accuracy of any information contained herein. Any use of this book is at your own risk. Enjoy!

✉ Contact

For corrections, please send an email to andrew@photosecrets.com. Instagram: photosecretsguides; Web: www.photosecrets.com

Table of Contents

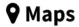 Maps

📍 Blue Ridge Parkway Virginia

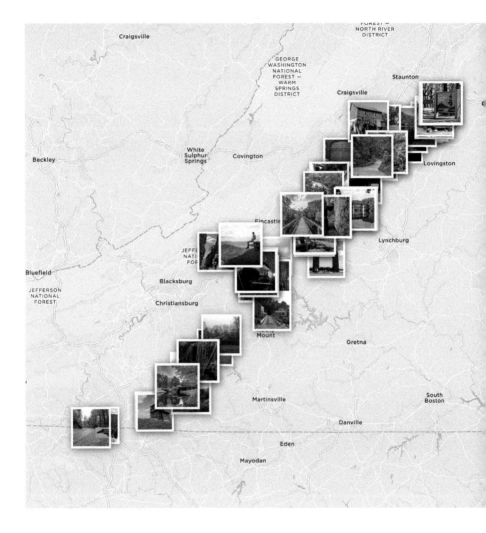

📍 Mileposts 000-020: Rockfish Gap area

Rockfish Gap is the start of the Blue Ridge Parkway, south of Shenandoah National Park and I-64 in Afton. There are ten overlooks in the first 20 miles.

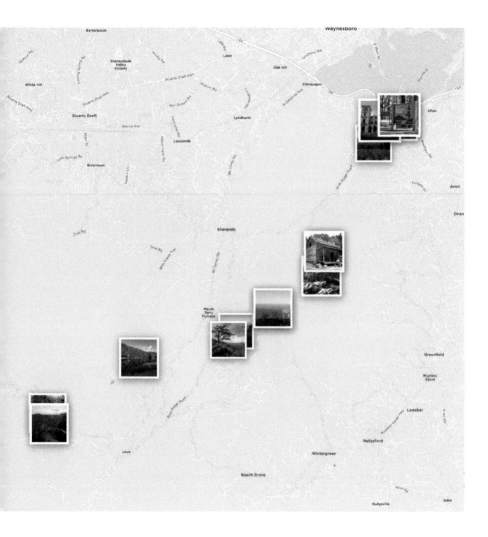

♀ Mileposts 020-060: Whetstone Ridge area

Whetstone Ridge area climbs the Blue Ridge Mountains, with diversions to Southern Virginia University in Buena Vista, and Washington and Lee University in Lexington.

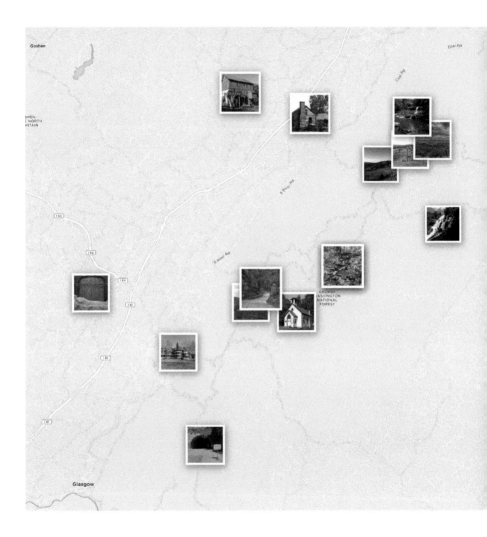

📍 Mileposts 060-063: Natural Bridge

Natural Bridge is a 15 mile (25 km) detour north, to a community named for a 215-foot-high (66m) natural arch, one of the tourist attractions of the new world that Europeans visited during the 18th and 19th centuries.

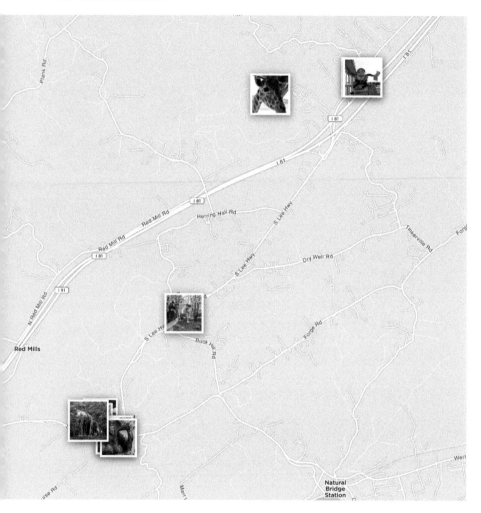

◉ Mileposts 063-100: Peaks of Otter area

Peaks of Otter was the first tourist spot on what later became the Blue Ridge Parkway. There are three mountains and a lake.

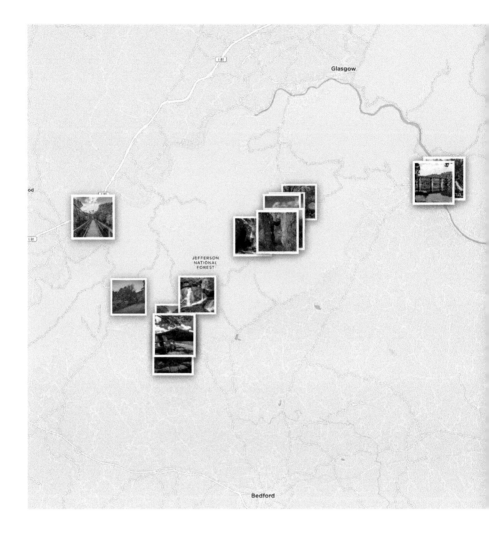

📍 Mileposts 100-120: Roanoke area

Roanoke is an independent city and the largest municipality in Southwest Virginia.

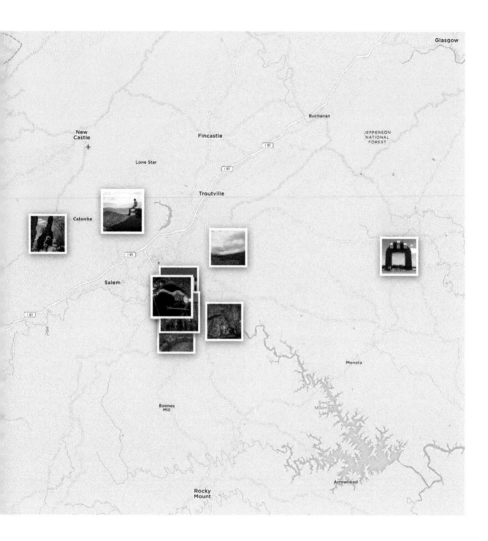

📍 Mileposts 120-170: Smart View area

Smart View is local lexicon for a spectacular vista, something we can all appreciate on the Blue Ridge Parkway.

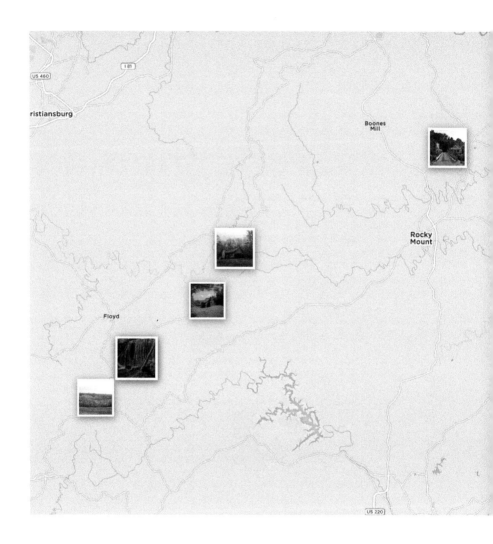

📍 Mileposts 170-180: Mabry Mill

Mabry Mill is a watermill dating from 1903 and possibly the most photographic building on the parkway.

♀ Mileposts 180-217: North Carolina state line

North Carolina state line marks almost the half-way point of the Blue Ridge Parkway, and the end of our 217 mile (350km) trip through Virginia.

A GREAT TRAVEL photograph, like a great news photograph, requires you to be in the right place at the right time to capture that special moment. Professional photographers have a short-hand phrase for this: "F8 and be there."

There are countless books that can help you with photographic technique, the "F8" portion of that equation. But until now, there's been little help for the other, more critical portion of that equation, the "be there" part. To find the right spot, you had to expend lots of time and shoe leather to walk around, track down every potential viewpoint, and essentially re-invent the wheel.

In my career as a professional travel photographer, well over half my time on location is spent seeking out the good angles. Andrew Hudson's PhotoSecrets does all that legwork for you, so you can spend your time photographing instead of wandering about. It's like having a professional location scout in your camera bag. I wish I had one of these books for every city I photograph on assignment.

PhotoSecrets can help you capture the most beautiful sights with a minimum of hassle and a maximum of enjoyment. So grab your camera, find your favorite PhotoSecrets spots, and "be there!"

Bob Krist has photographed assignments for *National Geographic, National Geographic Traveler, Travel/Holiday, Smithsonian,* and *Islands.* He won "Travel photographer of the Year" from the Society of American Travel Writers in 1994, 2007, and 2008 and today shoots video as a Sony Artisan Of Imagery.

For *National Geographic,* Bob has led round-the-world tours and a traveling lecture series. His book *In Tuscany* with Frances Mayes spent a month on *The New York Times'* bestseller list and his how-to book *Spirit of Place* was hailed by *American Photographer* magazine as "the best book about travel photography."

After training at the American Conservatory Theater, Bob was a theater actor in Europe and a newspaper photographer in his native New Jersey. The parents of three sons, Bob and his wife Peggy live in New Hope, Pennsylvania.

Welcome

<div align="right">By Andrew Hudson</div>

THANK YOU for reading PhotoSecrets. As a fellow fan of travel and photography, I hope this guide will help you quickly find the most visually stunning places, and come home with equally stunning photographs.

 PhotoSecrets shows you all the best sights. Flick through, see the classic shots, and use them as a departure point for your own creations. Get ideas for composition and interesting viewpoints. See what piques your interest. Know what to shoot, why it's interesting, where to stand, when to go, and how to get great photos. Now you can spend less time researching and more time photographing.

The idea for PhotoSecrets came during a trip to Thailand, when I tried to find the exotic beach used in the James Bond movie *The Man with the Golden Gun*. None of the guidebooks I had showed a picture, so I thought a guidebook of postcard photos would be useful for us photographers. Twenty-plus years later, you have this guide. Thanks!

Now, start exploring — and take lots of photos!

Andrew Hudson

Andrew Hudson started PhotoSecrets in 1995 and has published 18 nationally-distributed color photography books. His first book won the Benjamin Franklin Award for Best First Book and his second won the Grand Prize in the National Self-Published Book Awards.

Andrew has photographed assignments for *Macy's*, *Men's Health* and *Seventeen*, and was a location scout for *Nikon*. His photos and articles have appeared in *National Geographic Traveler*, *Alaska Airlines*, *Shutterbug*, *Where Magazine*, and *Woman's World*.

Born in England, Andrew has a degree in Computer Engineering from the University of Manchester and was previously a telecom and videoconferencing engineer. Andrew and his wife Jennie live with their two kids and two chocolate Labs in San Diego, California.

ⓘ Introduction

👁 At a Glance	
ⓘ **Name:**	Blue Ridge Parkway
🌐 **GPS:**	37.3092624, -79.8643758
🏆 **Awards:**	National Parkway, All-American Road, America's longest linear park
📢 **Fame:**	the most visited unit of the National Park System every year since 1946 except three (1949, 2013, and 2016)
Established:	June 30, 1936
Visitors:	12,877,368 (in 2013)
Governing body:	National Park Service
Miles in Virginia:	217

The **BlueRidge Parkway** is a National Parkway and All-American Road, noted for its scenic beauty. The parkway, which is America's longest linear park, runs for 469 miles (755 km) through 29 Virginia and North Carolina counties, linking Shenandoah National Park to Great Smoky Mountains National Park. It runs mostly along the spine of the Blue Ridge, a major mountain chain that is part of the Appalachian Mountains. Its southern terminus is at U.S. 441 on the boundary between Great Smoky Mountains National Park and the Cherokee Indian Reservation in North Carolina, from which it travels north to Shenandoah National Park in Virginia. The roadway continues through Shenandoah as Skyline Drive, a similar scenic road which is managed by a different National Park Service unit.

The parkway has been the most visited unit of the National Park System every year since 1946 except three (1949, 2013, and 2016). Land on either side of the road is owned and maintained by the National Park Service, and in many places parkway land is bordered by United States Forest Service property. The parkway was on North Carolina's version of the America the Beautiful quarter in 2015.

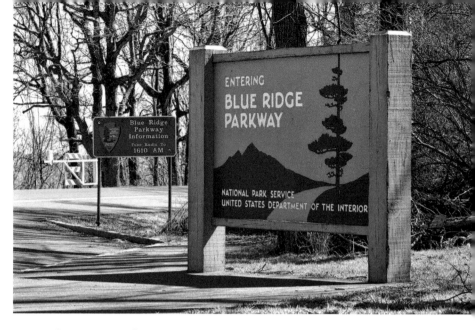

Entering Blue Ridge Parkway sign. Every great travel story needs a title picture, so let your first photo be a selfie by this sign to say "Me (and my friends/family), Entering Blue Ridge Parkway."

Set your trip odometer now, for this is Milepost 0 and every attraction along the way is located by miles from here.

Nearby is Virginia's Rockfish Gap Tourist Information Center (a half mile west at 130 Afton Circle) with brochures, maps, and friendly faces to help your journey.

✉ **Addr:**	Blue Ridge Pkwy, Afton VA 22920	♀ **Where:**	38.03046 -78.85768
♀ **Milepost:**	0.1	☽ **When:**	Afternoon
◉ **Look:**	South-southeast	↔ **Far:**	28 m (92 feet)

ENTERING
BLUE RIDGE
PARKWAY

NATIONAL PARK SERVICE
UNITED STATES DEPARTMENT OF THE INTERIOR

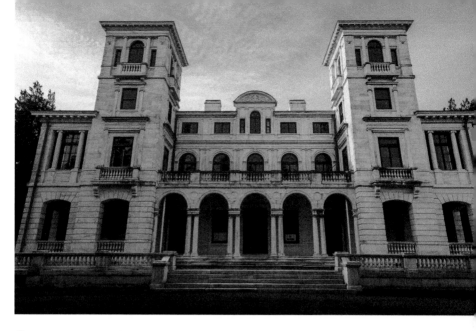

Swannanoa is an Italian Renaissance Revival villa above Rockfish Gap. Built in 1912 by millionaire and philanthropist James H. Dooley (1841–1922), it is partially based on buildings in the Villa Medici, Rome.

This "summer place" reportedly took over 300 artisans eight years to build. There are gold plumbing fixtures, an elevator, a dumbwaiter, and a 4,000-piece Tiffany stained-glass window of Mrs Dooley.

In 1928, when the bequeathed building had become a country club, Calvin Coolidge had Thanksgiving dinner at the mansion.

✉ **Addr:**	497 Swannanoa Ln, Afton VA 22920	♀ **Where:**	38.028195 -78.868509	
♀ **Milepost:**	0.15 + 0.8	☾ **When:**	Morning	
👁 **Look:**	West-southwest	W **Wik:**	Swannanoa_(mansion)	

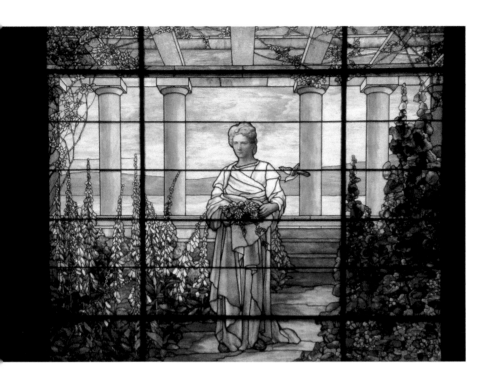

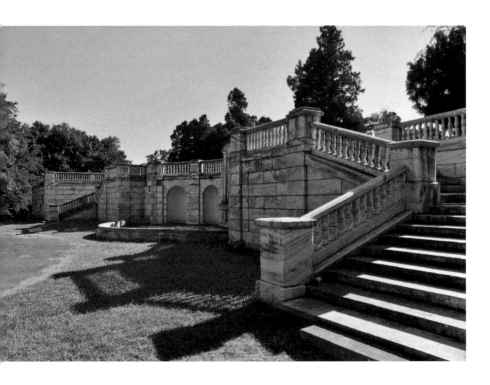

Afton Overlook, with a view southeast of Afton Valley, is the first overlook on the parkway. There are around 280 overlooks along the 469-mile Blue Ridge Parkway, an average of one every 1.7 miles.

During the 1900s, much of the area was logged so when the parkway was constructed in 1935, scenic views abounded. Now that second generation trees and brush have grown, many overlooks are obstructed, but there are still more than enough to photograph.

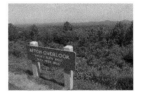

✉ **Addr:**	Afton Overlook, Afton VA 22920	♀ **Where:**	38.027781 -78.85783	
♀ **Milepost:**	0.2	◐ **When:**	Afternoon	
👁 **Look:**	South-southeast	↔ **Far:**	8 km (4.78 miles)	

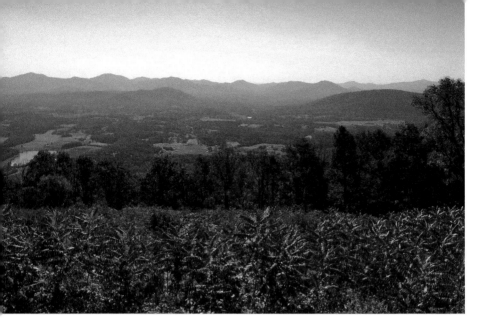

View Rockfish Valley looks southeast across the southern portion of Afton Valley (left) and down to Rockfish Valley (center). The water on the left is Baldwin Pond, site of Afton Mountain Vineyards.

✉ **Addr:**	Blue Ridge Pkwy, Afton VA 22920	♀ **Where:**	38.018231 -78.871819	
♀ **Milepost:**	1.5	☾ **When:**	Afternoon	
👁 **Look:**	Southeast	↔ **Far:**	5 km (3.13 miles)	

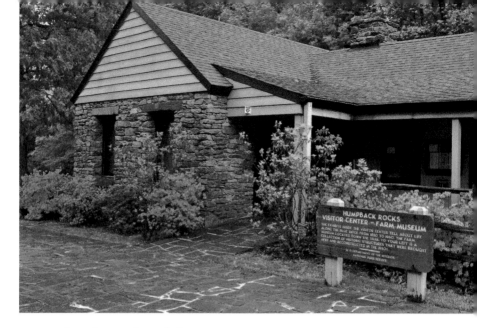

Humpback Rocks Visitor Center is the first National Park
Service facility. Open seasonally with a ranger, brochures, maps, and
exhibits about life along the Blue ridge from 1850 to 1950. A short trail
leads to a collection of historic structures.

The early European settlers of the Appalachian Mountains forged
a living from the native materials. Hickory, chestnut and oak trees
provided nuts for food, logs for building and tannin for curing hides,
while the rocks were put to use as foundations and chimneys for the
houses and in stone fences to control wandering livestock. Many self-
sufficient farms sprang up in the Humpback Mountain area.

✉ **Addr:**	MP5.8 Blue Ridge Pkwy, Lyndhurst VA 22952	📍 **Where:**	37.972781 -78.899359	
📍 **Milepost:**	5.8	🌓 **When:**	Morning	
👁 **Look:**	Southwest	↔ **Far:**	9 m (30 feet)	

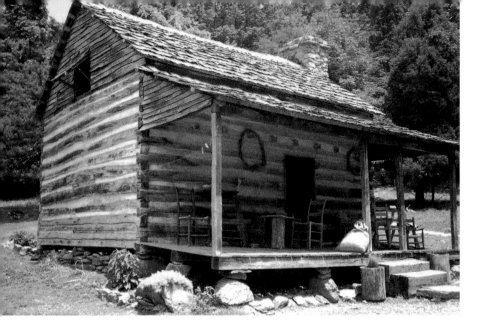

Historic Mountain Farm

Historic Mountain Farm (also known as the Outdoor Farm Museum) is a collection of historic buildings that help tell the story of early life in the mountains. The buildings were moved here during construction of the parkway.

Included are a cabin (above) with interior furnishings, and a Root Cellar and Plunder Shed (later page).

This is an easy .25 mile hike along a gravel path that can accommodate wheelchairs.During the summer months, costumed interpreters demonstrate southern Appalachian mountain life at the turn of the 20th century.

✉ **Addr:**	MP 5.8 Blue Ridge Parkway, Lyndhurst VA 22952	📍 **Where:**	37.971703 -78.899319
📍 Milepost:	5.8	🕐 **When:**	Afternoon
👁 **Look:**	Southeast	↔ **Far:**	40 m (130 feet)

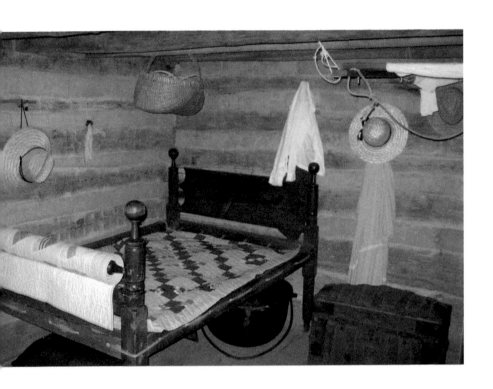

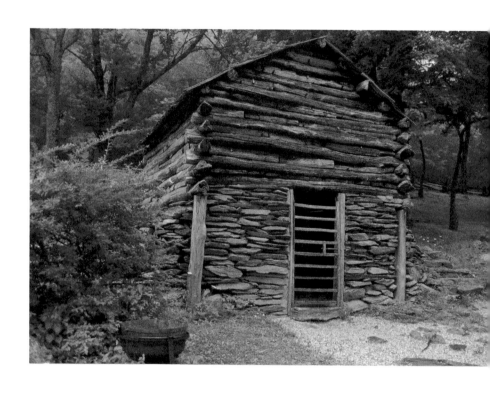

Humpback Rock is a massive greenstone outcrop near the peak of Humpback Mountain.

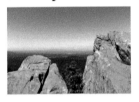 From the south end of Humpback Gap Parking Area, hike one mile south, including a strenuous 700-foot climb. There are photogenic rocks provide and great views over the wooded Rockfish and Shenandoah Valleys.

An additional one mile hike leads to the summit of Humpback Mountain to view ridges to the north.

✉ **Addr:**	Blue Ridge Pkwy, Lyndhurst VA 22952	⚲ **Where:**	37.961179 -78.900812	
⚲ **Milepost:**	6.0 + 0.6	⏱ **When:**	Afternoon	
👁 **Look:**	North	W **Wik:**	Humpback_Rock	

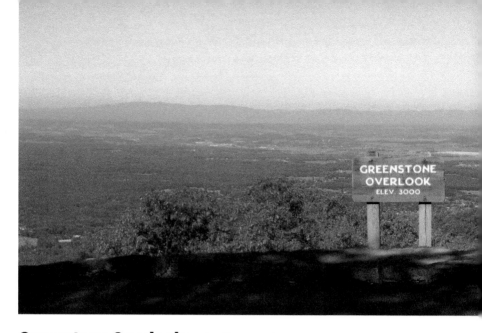

Greenstone Overlook is the first parkway viewpoint that looks west. To the northwest is the city of Staunton and the mountain ridge forming the border with West Virginia.

✉ **Addr:**	Blue Ridge Parkway, Lyndhurst VA 22952	♀ **Where:**	37.9472913 -78.9279152
♀ **Milepost:**	8.8	◷ **When:**	Morning
👁 **Look:**	Northwest	↔ **Far:**	54 km (34 miles)

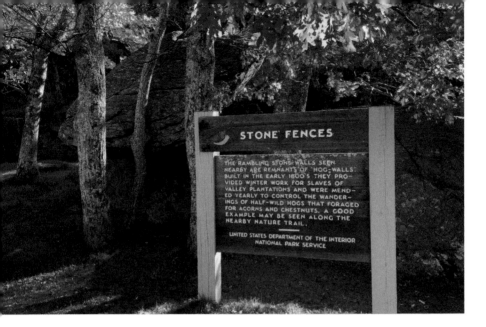

Stone Fences at Greenstone Overlook are rock walls built in the early 1800s. Plantation slaves made these to control the wanderings of half-wild hogs.

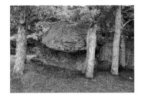

✉ **Addr:**	Greenstone Overlook, Lyndhurst VA 22952	♀ **Where:**	37.947133 -78.927906
♀ **Milepost:**	8.8	☽ **When:**	Afternoon
👁 **Look:**	East-southeast	↔ **Far:**	7 m (23 feet)

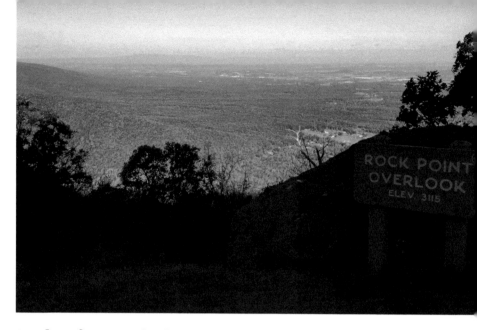

Rock Point Overlook looks northwest over Sherando.

✉ **Addr:**	Blue Ridge Pkwy, Roseland VA 22967	⚲ **Where:**	37.937433 -78.948553
⚲ **Milepost:**	10.4	☾ **When:**	Morning
👁 **Look:**	Northwest	↔ **Far:**	4.91 km (3.05 miles)

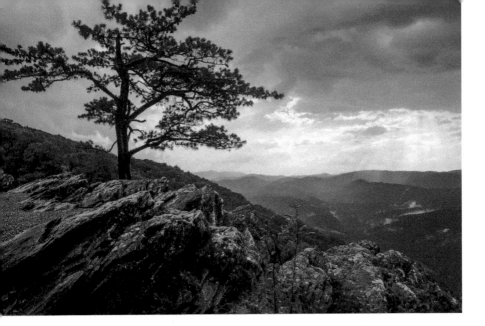

Ravens Roost Overlook is a picturesque lookout with a lone pine tree on jagged rocks. This is the first overlook with views over forested mountain ridges rather than municipal valleys.

Copper plates on the stone wall allow you to "sight over cones" to points of interest.

✉ **Addr:**	Blue Ridge Pkwy, Lyndhurst VA 22952	♀ **Where:**	37.933692 -78.952838	
♀ **Milepost:**	10.7	☽ **When:**	Morning	
👁 **Look:**	Northwest	↔ **Far:**	2.26 km (1.41 miles)	

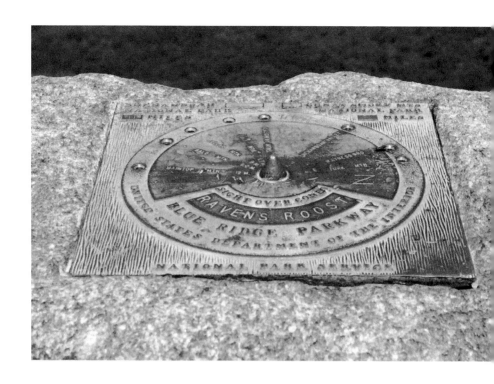

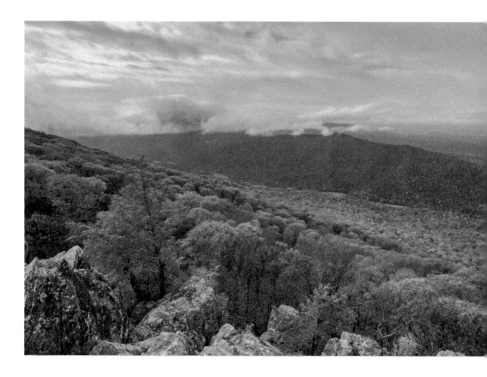

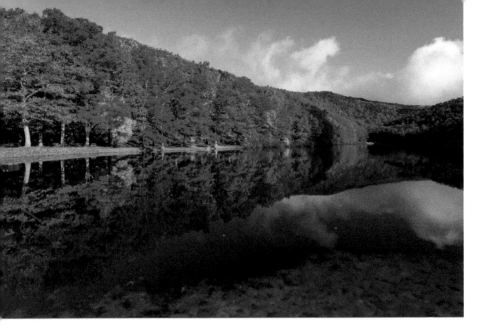

Sherando Lake is a 25-acre reservoir, known locally as the jewel of the Blue Ridge Mountains, where visitors enjoy hiking, picnicking in the shade, fishing in the lakes, or swimming and relaxing on the sandy beach. This view is from the dam.

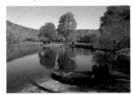

The lake is 4.1 miles west from the parkway on Reeds Gap Road (VA-664, MP13.2), the first intersection since the start of the trip.

✉ **Addr:**	Sherando Lake, South River VA 22952	♀ **Where:**	37.9259071 -79.0029526	
♀ **Milepost:**	13.2 + 4.1	☽ **When:**	Afternoon	
👁 **Look:**	South	↔ **Far:**	230 m (750 feet)	

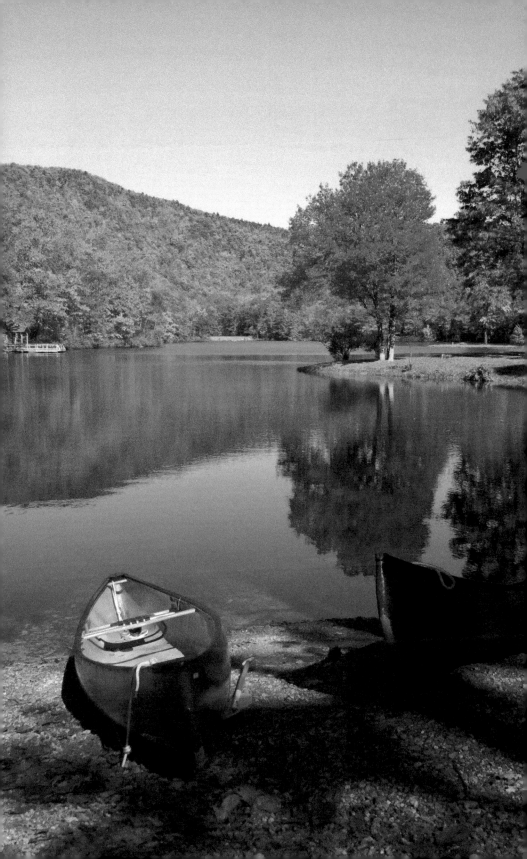

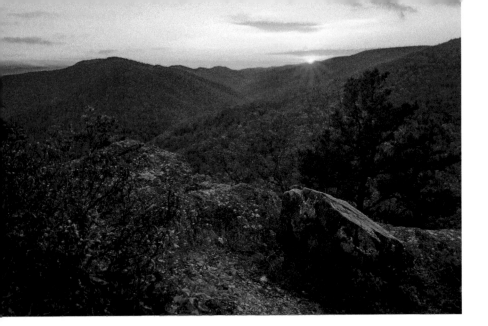

20-Minute Cliff looks west over the ridges along White Rock Creek. This shot was taken at sunset.

The name of the rock face comes from its use as a clock. In the summer, the people in the valley know that dusk will fall twenty minutes after sunlight hits the cliff.

✉ **Addr:**	Blue Ridge Pkwy, Vesuvius VA 24483	♀ **Where:**	37.8975182 -79.0538559
♀ **Milepost:**	19.0	◑ **When:**	Morning
👁 **Look:**	West-southwest	↔ **Far:**	1.25 km (0.77 miles)

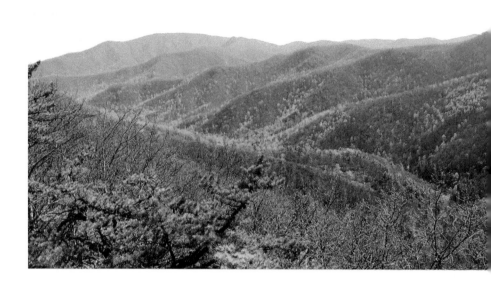

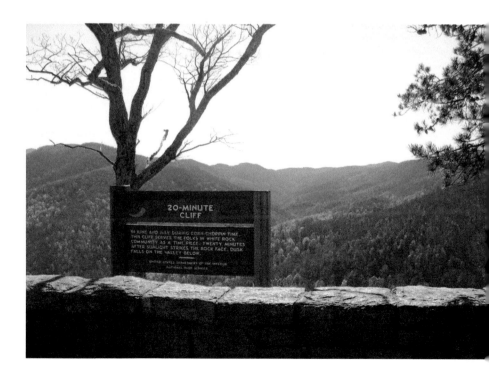

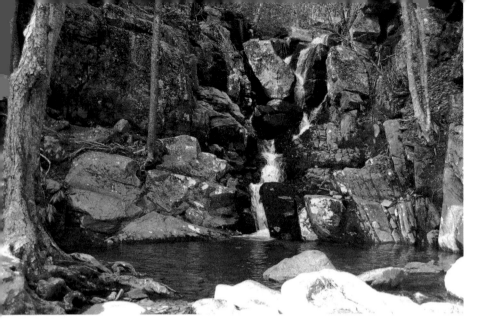

White Rock Falls is the first of a dozen waterfalls accessible on the parkway. The 40-foot cascade on White Rock Creek is fronted by a round swimming hole, and reached by a 1.2 mile moderate hike.

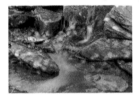

From the Slacks Overlook, cross the parkway and turn left. About 300 feet from the parking lot is a sign for the trail entrance.

Like most parkway waterfalls, spring is best for plentiful water; late summer and early fall can find the rocks dry.

✉ **Addr:**	White Rock Falls, Vesuvius VA 24483	♀ **Where:**	37.902023 -79.0547602
♀ **Milepost:**	19.9 + 2.5	☾ **When:**	Afternoon
◉ **Look:**	East	↔ **Far:**	0 m (0 feet)

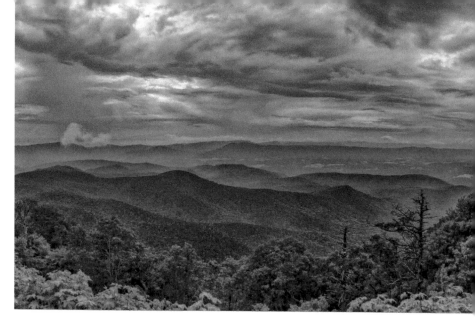

View Fork Mountain finds Fork Mountain dividing the north and south forks of the Tye River.

✉ **Addr:**	Blue Ridge Pkwy, Vesuvius VA 24483	♥ **Where:**	37.91085 -79.085324
♥ **Milepost:**	23.0	☾ **When:**	Morning
👁 **Look:**	South	↔ **Far:**	4.18 km (2.60 miles)

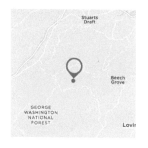

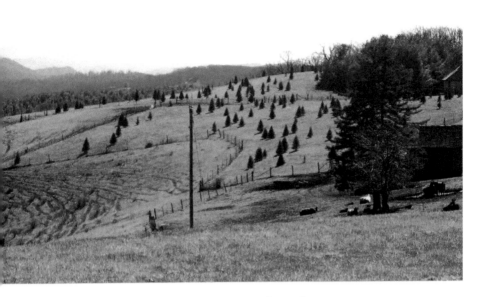

Skylark Nature Preserve and Lodge is a bird-hunting retreat.

✉ **Addr:**	24981 Blue Ridge Pkwy, Raphine VA 24472	📍 **Where:**	37.903185 -79.108869	
📍 **Milepost:**	24	🕐 **When:**	Morning	
👁 **Look:**	Southwest	↔ **Far:**	440 m (1430 feet)	

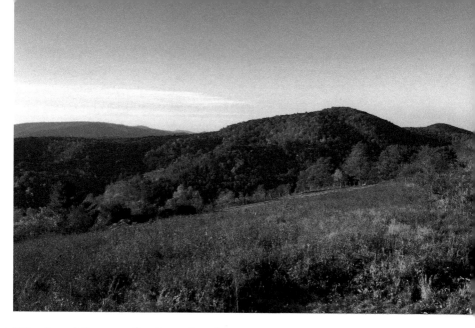

Big Spy Mountain Overlook has a short walk to a pasture with views of a rocky dome called Big Spy.

✉ **Addr:**	Blue Ridge Parkway, Laurel Springs NC 28644	📍 **Where:**	37.8914453 -79.139762
📍 **Milepost:**	26.4	🕐 **When:**	Morning
👁 **Look:**	Southwest	↔ **Far:**	1.67 km (1.04 miles)

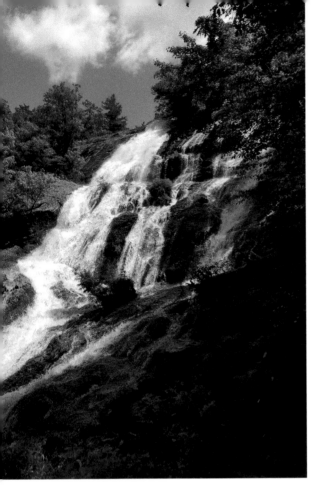

Crabtree Falls is one of the tallest sets of waterfalls in the United States east of the Mississippi River. It is a series of cascading waterfalls, with five major cascades, the tallest of which drops about 400 feet (120 m), and several smaller cascades, all over a total distance of approximately 2,500 feet (760 m) horizontally.

A scenic and moderate 2.7-mile (4.3 km) trail winds along the creek past all five cascades, with viewing platforms and steps.

From MP 27, go east 6.4 miles.

The name of the falls is thought to have come from William Crabtree, who settled in this part of Virginia in 1777.

✉ **Addr:**	Crabtree Falls, Massies Mill VA 22976	♥ **Where:**	37.8431931 -79.0744717
♥ **Milepost:**	27.0 + 6.2	◑ **When:**	Afternoon
👁 **Look:**	East-southeast	W **Wik:**	Crabtree_Falls

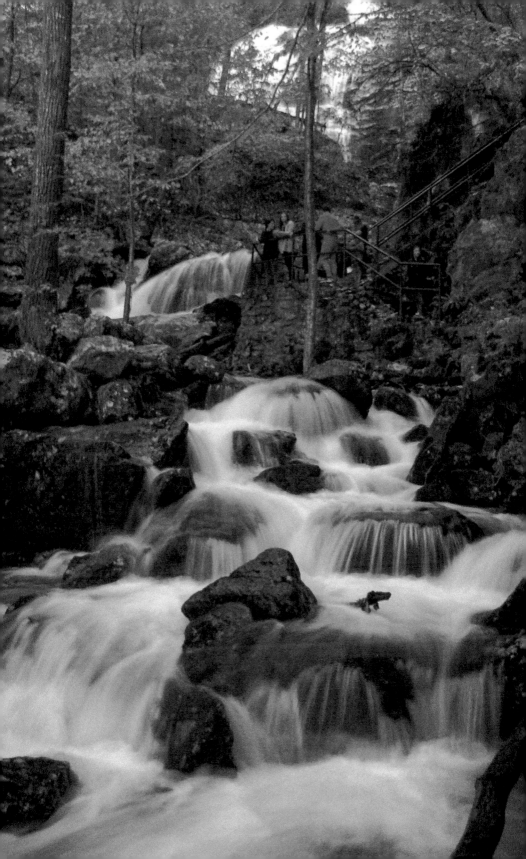

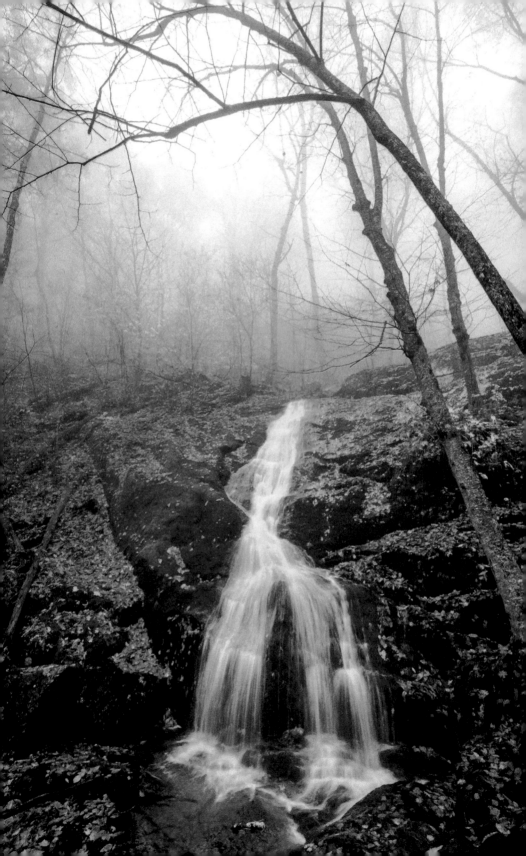

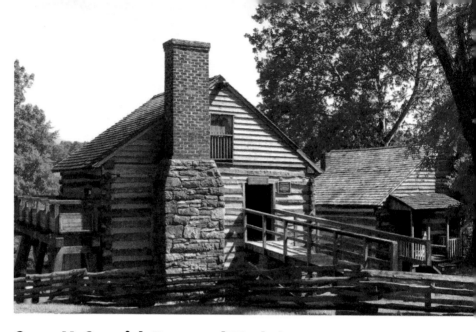

Cyrus McCormick Farm and Workshop is the birthplace of

the combine harvester. At the family farm, Cyrus McCormick, along with his father and brothers, developed a mechanical reaper which, by the end of the 19th century, increased harvesting by 24 times. Instead of a family to toiling all day to harvest crops, a single farmer merely operated the machine and the reaper would do the rest of the work. Their company merged to form International Harvester.

The farm, dating from 1822, is now a museum run by the Virginia Agricultural Experimental Station of Virginia Tech. Buildings include a grist mill (left) and blacksmith shop (right).

From Tye River Gap (MP 27), take SR-56 west through Steeles Tavern.

✉ **Addr:**	128 Cyrus McCormick Cir, Raphine VA 24472	♀ **Where:**	37.932151 -79.213324	
♀ **Milepost:**	27.0 + 6.3	☽ **When:**	Morning	
👁 **Look:**	North	W **Wik:**	Cyrus_McCormick_Farm	

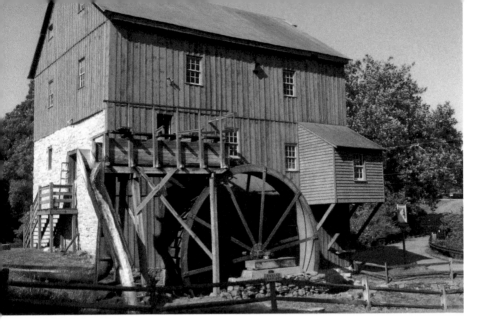

Kennedy-Wade Mill is a grist mill in Raphine, about a mile past McCormick Farm.

Built c. 1750 by Captain Joseph Kennedy, the mill was rebuilt by James F. Wade in 1882 and is still functioning today. With a 21-foot overshot water wheel to power millstones, the mill grinds flour which is shipped to restaurants and livestock farmers.

✉ **Addr:**	Wades Mill, Walkers Creek VA 24472	♀ **Where:**	37.948936 -79.286289
♀ **Milepost:**	27.0 + 7.5	☽ **When:**	Afternoon
👁 **Look:**	Northeast	W **Wik:**	Kennedy-Wade_Mill

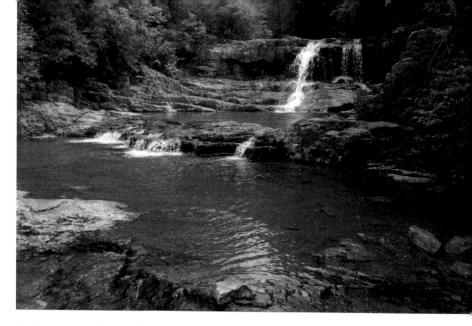

Saint Mary's Falls is a scenic waterfall and swimming hole. The two-mile hike is challenging and rocky, and requires walking through the water.

The Saint Mary's River gorge was mined for manganese ore and iron ore from the early 1900s until the mines were abandoned in the 1950s. Today, Saint Mary's Wilderness is the largest Virginia Wilderness on national forest land.

Although geographically close to the parkway, the waterfall is a 30 minute drive. From Tye River Gap at MP 27, take SR-56 west to Steeles Tavern, then head north on Lee Highway (SR-11) and east on St Mary's Road to the trailhead.

✉ **Addr:**	Saint Mary's Wilderness, Raphine VA 24472	♀ **Where:**	37.929563 -79.107032	
♀ **Milepost:**	27.0 + 12.4	◐ **When:**	Afternoon	
◉ **Look:**	Southeast	W **Wik:**	Saint_Mary's_Wilderness	

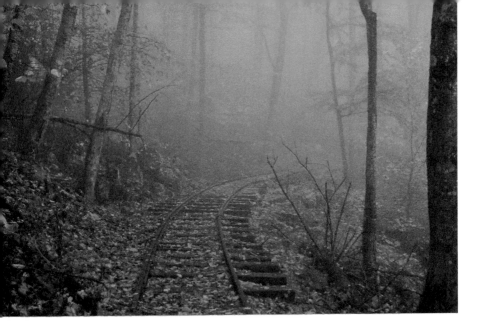

Old Logging Railroad

Old Logging Railroad at Yankee Horse Ridge has a photogenic, 1920s-era curving section of railroad tracks through the forest. This short stretch is a reconstructed part of a 50-mile-long railroad, operated by the South River Lumber Company's Irish Creek Railroad from 1919 to 1939. Logging and fires destroyed most of the virgin forests of the Blue Ridge: today's trees are mostly second growth.

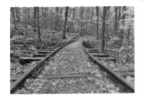

Park at MP 34.4 Yankee Horse Overlook Parking Area and walk up the rock steps to the track, which includes a trestle over a stream.

✉ **Addr:**	Blue Ridge Pkwy, Montebello VA 24464	♀ **Where:**	37.809397 -79.179564	
♀ **Milepost:**	34.4 + 0.2	◑ **When:**	Morning	
👁 **Look:**	South-southwest	↔ **Far:**	23 m (75 feet)	

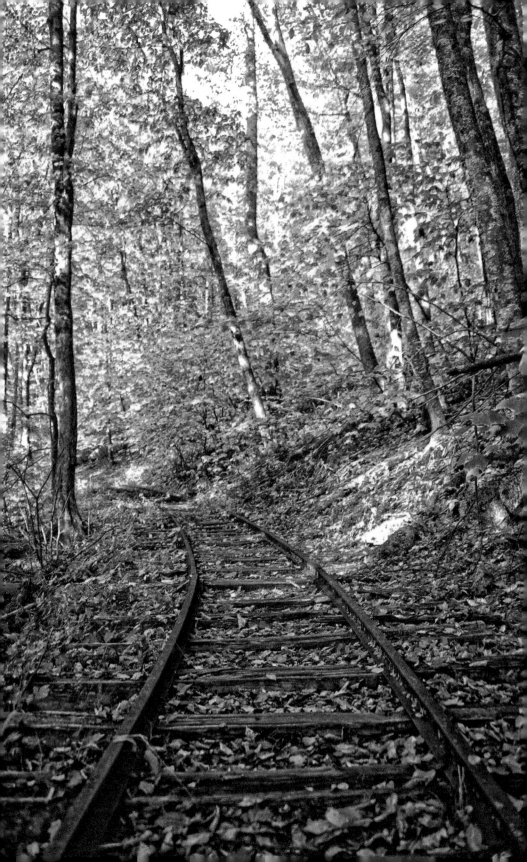

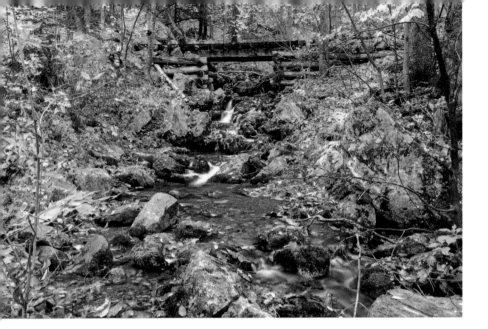

Irish Creek Railroad Trestle is a scenic wooden bridge over a stream with small waterfalls. This view is from just off the Yankee Horse Ridge Parking Area and downstream of Wigwam Falls.

✉ **Addr:**	Blue Ridge Pkwy, Montebello VA 24464	♀ **Where:**	37.809388 -79.179656
♀ **Milepost:**	34.4 + 0.2	☽ **When:**	Afternoon
👁 **Look:**	Southeast	↔ **Far:**	9 m (30 feet)

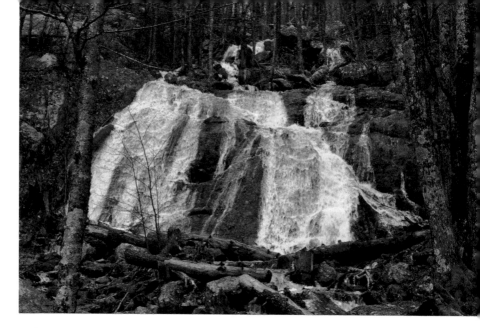

Wigwam Falls is a 30-foot cascade which can be photographed from a narrow bridge. The waterfall is a short hike from Yankee Horse Ridge Parking Area and the Old Logging Railroad.

✉ Addr:	Blue Ridge Pkwy, Montebello VA 24464	◉ Where:	37.808546 -79.179255
◉ Milepost:	34.4 + 0.6	◑ When:	Afternoon
👁 Look:	Southeast	↔ Far:	23 m (75 feet)

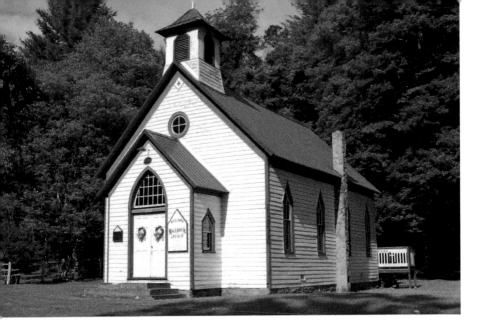

Macedonia Methodist Church is a Gothic Revival style historic church built in 1896. The one-story, frame church has a gable roof with front bell tower.

The church is a five mile (8 km) detour south from Irish Creek at MP 37.5. Take state routes 605 to 633 to 634.

✉ **Addr:**	1408 Coffeytown Rd, Vesuvius VA 24483	♀ **Where:**	37.772287 -79.227660
♀ **Milepost:**	37.5 + 5.0	☽ **When:**	Afternoon
👁 **Look:**	East-northeast	W **Wik:**	Macedonia_Methodist_Church

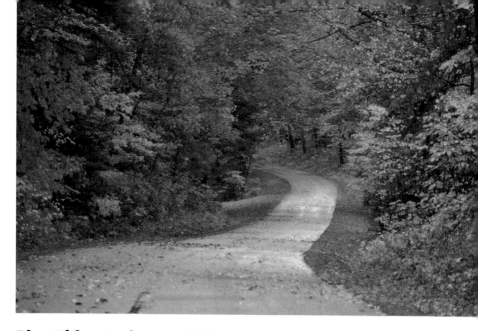

Blue Ridge Parkway at MP 41 is a photogenic curving section of parkway with fall color in October.

✉ **Addr:**	Blue Ridge Pkwy, Vesuvius VA 24483	♀ **Where:**	37.791146 -79.264984
♀ **Milepost:**	41	◑ **When:**	Afternoon
👁 **Look:**	East-northeast	↔ **Far:**	230 m (740 feet)

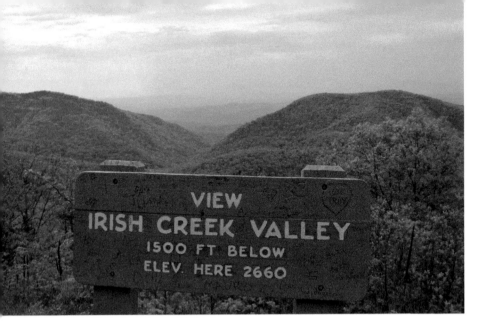

View Irish Creek Valley looks west down Whites Run toward Lexington.

✉ **Addr:**	Blue Ridge Pkwy, Vesuvius VA 24483	📍 **Where:**	37.78003 -79.275649
📍 **Milepost:**	42.2	☾ **When:**	Morning
👁 **Look:**	West	↔ **Far:**	2.15 km (1.33 miles)

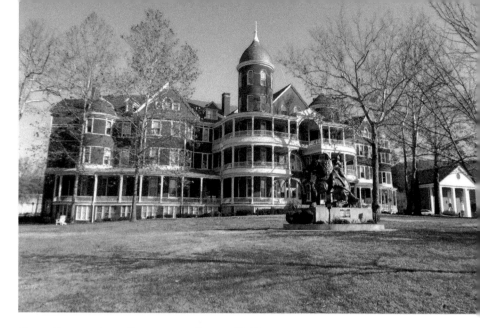

Southern Seminary Main Building is the main hall of Southern Virginia University (SVU).

Founded in 1867 as a school for girls, the university embraces the values of The Church of Jesus Christ of Latter-day Saints (LDS Church). The main building was originally Hotel Buena Vista, built in 1890 in an eclectic combination of Queen Anne and French Renaissance style architecture. It features round towers and three-level wooden galleries.

✉ **Addr:**	1 University Hill Dr, Buena Vista VA 24416	♀ **Where:**	37.740035 -79.350985
♀ **Milepost:**	45.0 + 4.4	◑ **When:**	Morning
👁 **Look:**	Southwest	W **Wik:**	Southern_Seminary_Main_Building

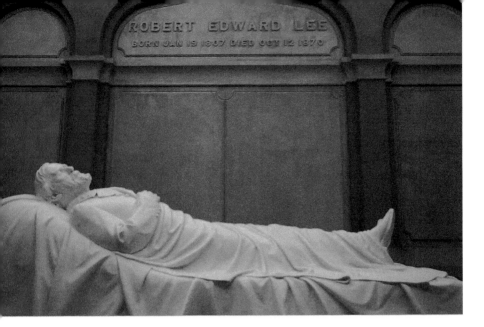

Lee Chapel is the burial site of Confederate commander Robert E. Lee. A recumbent statue of him decorates this Victorian brick church at Washington and Lee University, a private liberal arts university in Lexington. Established in 1749, the university is a colonial-era college and the ninth-oldest institution of higher learning in the United States.

The chapel was constructed 1867–68 at the request of Robert E. Lee, who was President of the University (then known as Washington College) at the time, and after whom the building is named.

✉ **Addr:**	11-17 Letcher Ave, Lexington VA 24450	♀ **Where:**	37.787938 -79.44225
♀ **Milepost:**	45.0 + 11.1	◑ **When:**	Afternoon
👁 **Look:**	Southeast	W **Wik:**	Lee_Chapel

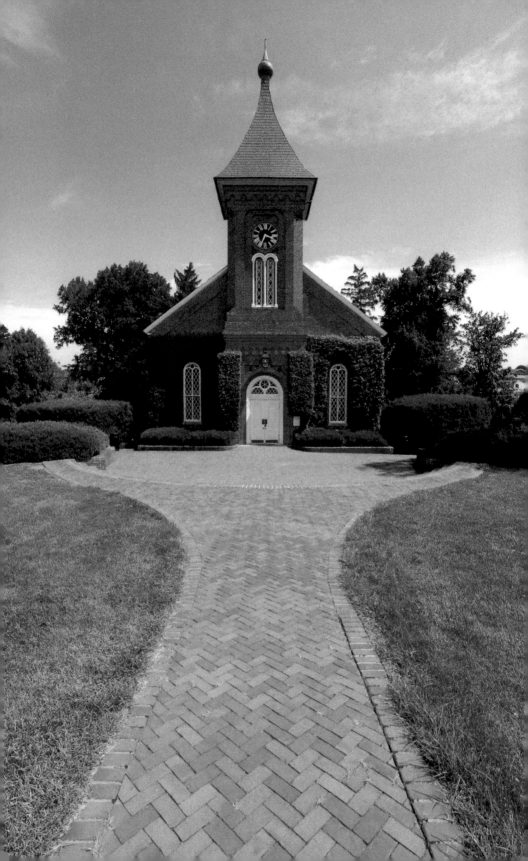

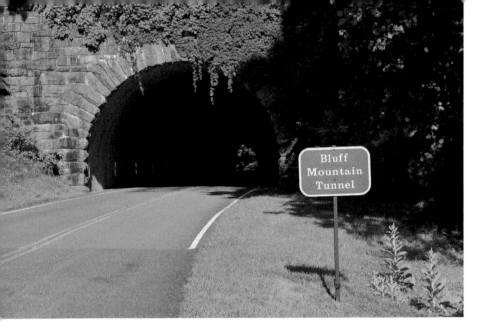

Bluff Mountain Tunnel is the only one of the 26 vehicle tunnels of the Blue Ridge Parkway that is in Virginia (the other 25 are in North Carolina). The tunnel is 630 feet (192 m) long.

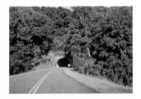

✉ **Addr:**	Blue Ridge Pkwy, Monroe VA 24574	♥ **Where:**	37.665420 -79.323112	
♥ **Milepost:**	53.1	☾ **When:**	Afternoon	
👁 **Look:**	North	W **Wik:**	Blue_Ridge_Parkway_tunnels	

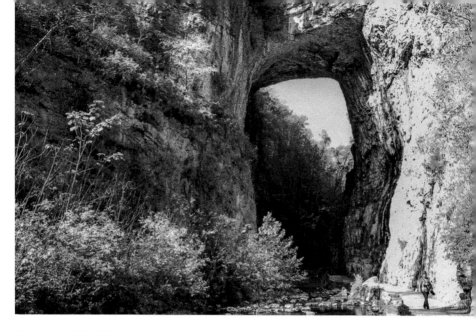

Natural Bridge is a giant natural arch, 215 feet (66 m) high and 90 feet (27 m) wide and was one of the first tourist attractions of the New World. Thomas Jefferson called it "the most sublime of nature's works" and purchased the land in 1774 from King George III of England for 20 shillings.

The arch is situated within a gorge, carved from the surrounding mountainous limestone terrain by Cedar Creek, a small tributary of the James River. U.S. Route 11 (Lee Highway) runs on top of the bridge but you can't see the gorge from the road. A flat walk of 1,400 feet (400 m) (fee required) leads to the arch.

✉ **Addr:**	6702 US-11, Natural Bridge VA 24578	♀ **Where:**	37.627777 -79.544191
♀ **Milepost:**	61.6 + 15.6	☽ **When:**	Morning
👁 **Look:**	West-northwest	W **Wik:**	Natural_Bridge_(Virginia)

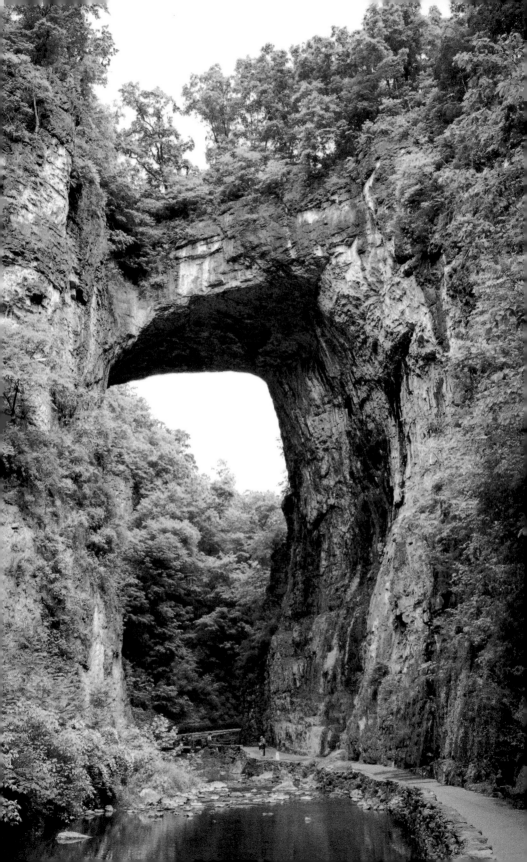

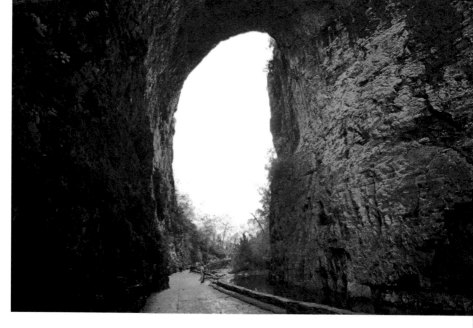

A view from underneath Natural Bridge from the north side, on Cedar Creek Trail.

✉ **Addr:**	Cedar Creek Trail, Natural Bridge VA 24578	♀ **Where:**	37.628133 -79.544935
♀ **Milepost:**	61.6 + 15.65	◷ **When:**	Afternoon
👁 **Look:**	South-southeast	↔ **Far:**	30 m (110 feet)

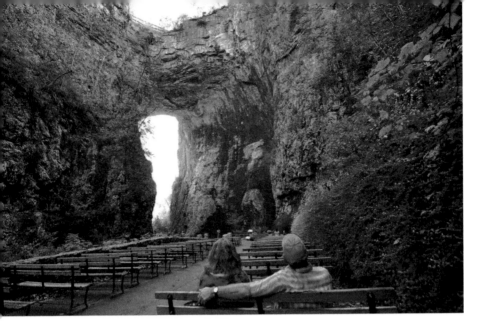

After walking beneath the bridge, the trail crosses Cedar Creak on a concrete bridge and opens up with benches for an amphitheater.

Further north is a recreated native village, a cave mine and a waterfall.

✉ **Addr:**	Cedar Creek Trail, Natural Bridge VA 24578	♀ **Where:**	37.628133 -79.544935
♀ **Milepost:**	61.6 + 15.7	◑ **When:**	Afternoon
👁 **Look:**	South-southeast	↔ **Far:**	30 m (110 feet)

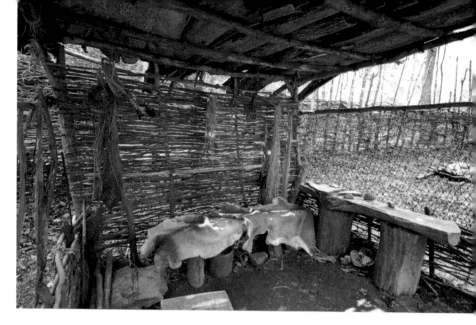

Monacan Indian Village is a recreated Native American settlement from the 1700s.

The exhibit is a partnership between the Monacan Indian Nation, Virginia Conservation Legacy Fund, and Virginia State Parks. Interpreters discuss shelter construction, hide tanning, mat and rope weaving, tool-making, gardening, harvesting, preparing meals, making pots, bowls and baskets.

✉ **Addr:**	Cedar Creek Trail, Natural Bridge VA 24578	♀ **Where:**	37.630661 -79.5474548
♀ **Milepost:**	61.6 + 15.8	◑ **When:**	Afternoon
👁 **Look:**	North	W **Wik:**	Monacan_people

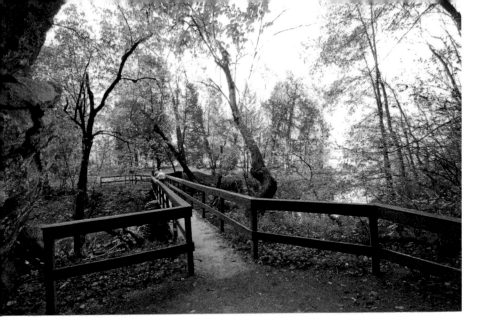

Saltpeter Mine Bridge over Cedar Creek to a cave mine.

Saltpeter was used to make gunpowder.

✉ **Addr:**	Cedar Creek Trail, Natural Bridge VA 24578	♀ **Where:**	37.629946 -79.5484527
♀ **Milepost:**	61.6 + 15.9	◑ **When:**	Morning
👁 **Look:**	North	W **Wik:**	Niter

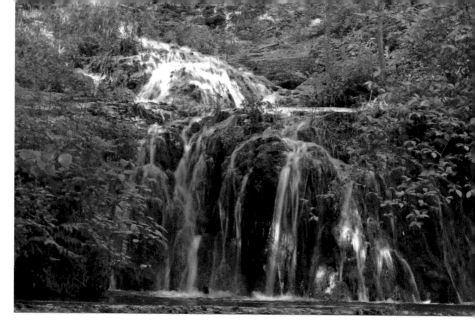

Lace Falls is a 30-foot waterfall at the far end of Cedar Creek Trail, upstream from Natural Bridge.

✉ **Addr:**	15 Appledore Lane, Natural Bridge VA 24578	♀ **Where:**	37.630076 -79.549626	
♀ **Milepost:**	61.6 + 16.2	☻ **When:**	Afternoon	
👁 **Look:**	East-northeast	↔ **Far:**	26 m (85 feet)	

 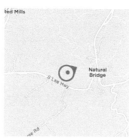

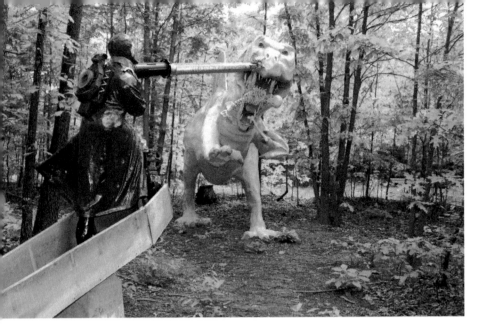

Dinosaur Kingdom II (also called Escape From Dinosaur Kingdom) is a tourist attraction in Natural Bridge with statues of a dinosaur attack on the Union Army. The park contains thirty fiberglass dinosaur statues, a smaller number of Union soldiers, and several other characters, including Abraham Lincoln and a gorilla in a cowboy hat. Dinosaur Kingdom, which opened in 2005, is the work of local artist Mark Cline, who also created nearby Foamhenge. The park's statues are built around the premise that paleontologists discovered dinosaurs in Virginia in 1863; when the Union Army attempted to use the dinosaurs as weapons, the dinosaurs turned on them. Cline's inspiration came from the movie The Valley of Gwangi, in which cowboys discovered living dinosaurs in a Mexican valley.

✉ **Addr:**	5781 S Lee Hwy, Natural Bridge VA 24578	♀ **Where:**	37.644706 -79.532594
♀ **Milepost:**	61.6 + 16.7	☽ **When:**	Afternoon
👁 **Look:**	North	W **Wik:**	Dinosaur_Kingdom

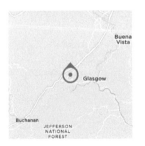

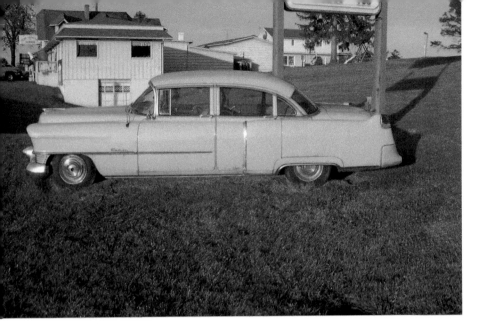

Pink Cadillac Diner in Natural Bridge is a 50s-style diner fronted by a real pink Cadillac. At the entrance are, naturally, sculptures of King Kong and Humpty Dumpty.

✉ **Addr:**	4347 S Lee Hwy, Natural Bridge VA 24578	♀ **Where:**	37.676807 -79.501534	
♀ **Milepost:**	61.6 + 19.5	☽ **When:**	Afternoon	
◉ **Look:**	North	↔ **Far:**	0 m (0 feet)	

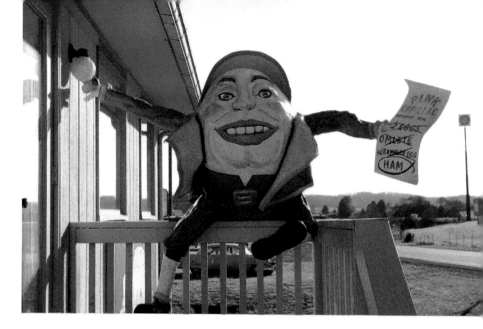

Humpty Dumpty encourages customers of the Pink Cadillac Diner to eat ham but not eggs.

✉ **Addr:**	4347 S Lee Hwy, Natural Bridge VA 24578	⚲ **Where:**	37.676778 -79.501206
⚲ **Milepost:**	61.6 + 19.5	◑ **When:**	Morning
◉ **Look:**	South-southwest	↔ **Far:**	24 m (79 feet)

Virginia Safari Park is a 180-acre drive-through zoo with free-roaming animals.

✉ **Addr:**	229 Safari Ln, Natural Bridge VA 24578	♀ **Where:**	37.674440 -79.517426
♀ **Milepost:**	61.6 + 20.4	☽ **When:**	Afternoon
👁 **Look:**	North	↔ **Far:**	0 m (0 feet)

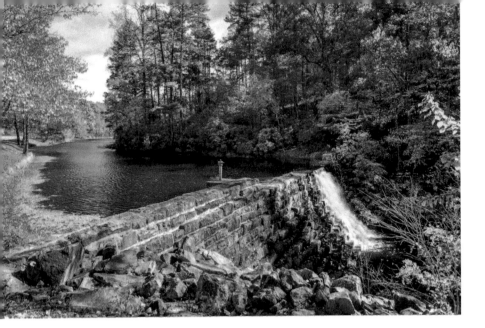

Otter Lake Dam features a scenic spillway from the seven-acre impoundment of Otter Creek. At the start of the Otter Lake Trail, a stone crossing allows you to photograph from below the dam.

✉ **Addr:**	Otter Lake, Monroe VA 24574	📍 **Where:**	37.556847 -79.3581
📍 **Milepost:**	63.2	◑ **When:**	Afternoon
👁 **Look:**	Southeast	↔ **Far:**	40 m (120 feet)

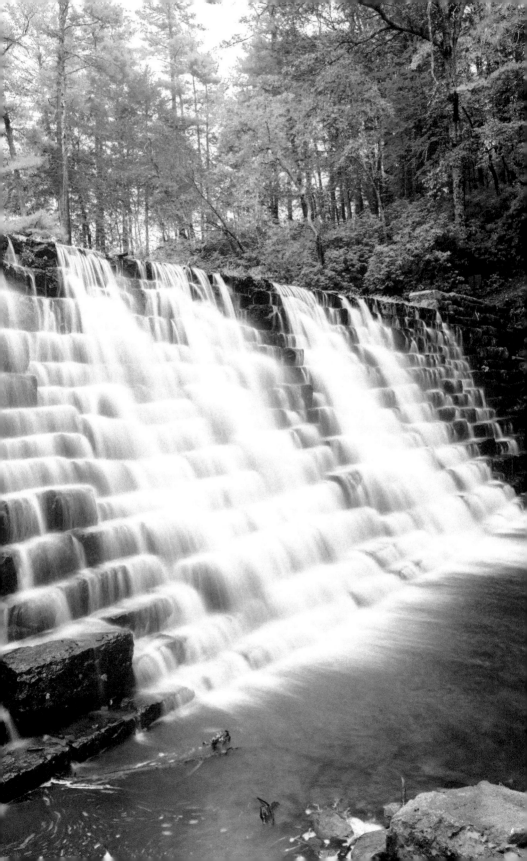

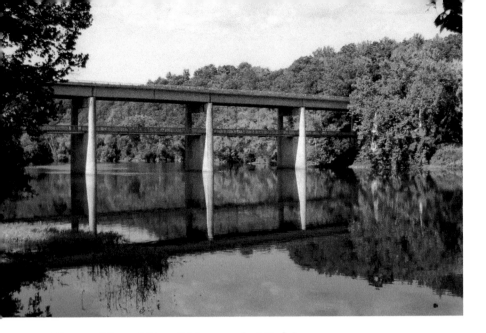

Harry Flood Byrd Memorial Bridge is a concrete crossing over the James River. It was dedicated in 1985 to an American newspaper publisher and political leader who helped create the Blue Ridge Parkway, as well as Shenandoah National Park, Skyline Drive, and the Virginia state park system.

✉ **Addr:**	Blue Ridge Pkwy, Big Island VA 24526	♀ **Where:**	37.553904 -79.3679	
♀ **Milepost:**	63.7	☽ **When:**	Afternoon	
👁 **Look:**	North-northeast	W **Wik:**	Harry_F._Byrd	

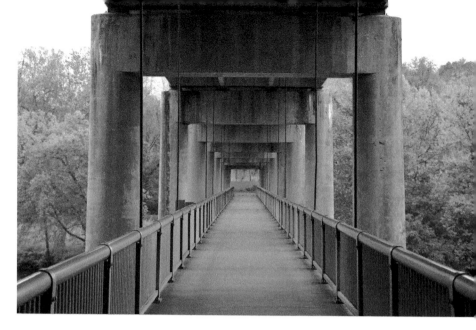

Underneath the Harry Flood Byrd Memorial Bridge is a pedestrian bridge. You can use the leading lines and repeating forms to make abstract images.

✉ **Addr:**	Blue Ridge Pkwy, Big Island VA 24526	📍 **Where:**	37.555308 -79.367182
📍 **Milepost:**	63.7	☽ **When:**	Afternoon
👁 **Look:**	North	↔ **Far:**	0 m (0 feet)

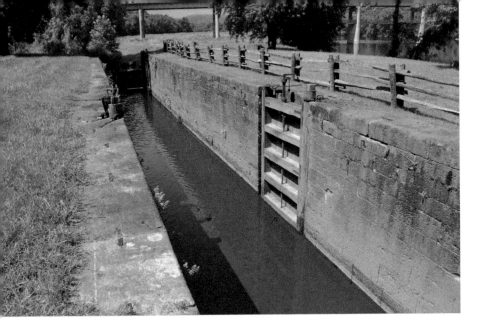

James River and Kanawha Canal is a lock, where gates
close and water flows in to raise a barge in stages over the mountains.

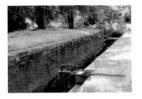

In 1790, the James River Company opened as the first commercial canal in the United States. The canal was intended to connect the Virginia counties west of the Blue Ridge, where rivers flow south, to the eastern counties and rivers that flow to the Atlantic coast to make Virginia become an economic powerhouse. But, with the advent of the railroad, the project was not completed.

✉ **Addr:**	12181 Lee Jackson Hwy, Big Island VA 24526	📍 **Where:**	37.553863 -79.368346	
📍 **Milepost:**	64.0 + 0.3	🕐 **When:**	Afternoon	
👁 **Look:**	North-northeast	W **Wik:**	James_River_and_Kanawha_Canal	

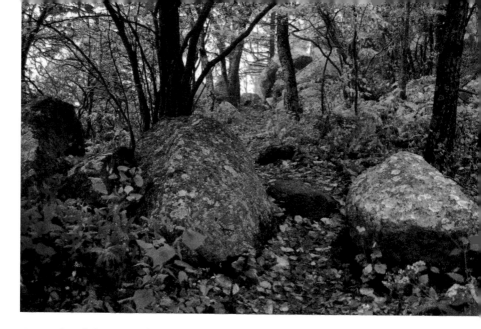

Appalachian Trail near Thunder Ridge Overlook.

The Appalachian National Scenic Trail, generally known as the Appalachian Trail or simply the A.T., is a marked hiking trail from Maine to Georgia, about 2,200 miles (3,500 km) long. Described as the longest hiking-only trail in the world, more than two million people are said to take a hike on part of the trail at least once each year.

The trail joins the parkway at Thunder Ridge and winds up to Apple Orchard Mountain two miles (3km) southwest.

✉ **Addr:**	Appalachian Trail, Natural Bridge Station VA 24579	♀ **Where:**	37.5403407 -79.4904784	
♀ **Milepost:**	74.7	◐ **When:**	Afternoon	
👁 **Look:**	North	W **Wik:**	Appalachian_Trail	

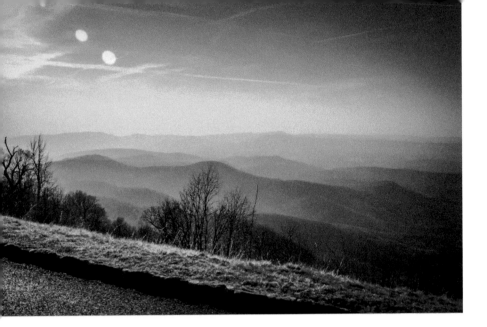

View Arnold Valley features mountain ridges.

✉ **Addr:**	Blue Ridge Pkwy, Bedford VA 24523	📍 **Where:**	37.5342522 -79.5014276	
📍 **Milepost:**	75.5	◑ **When:**	Morning	
👁 **Look:**	Southwest	↔ **Far:**	170 m (570 feet)	

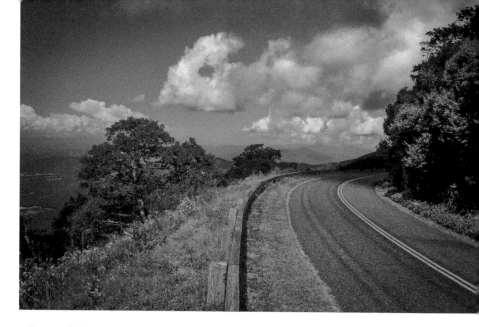

Blue Ridge Parkway at MP 75.8 includes a wooden crash
barrier. The nearest overlook is View Arnold Valley.

✉ **Addr:**	Blue Ridge Pkwy, Bedford VA 24523	♀ **Where:**	37.5322648 -79.5061336
♀ **Milepost:**	75.8	◑ **When:**	Afternoon
👁 **Look:**	Northeast	↔ **Far:**	80 m (270 feet)

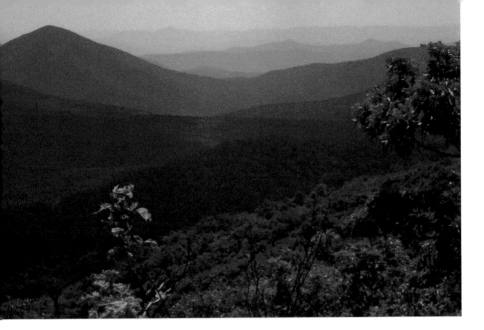

Apple Orchard Mountain Overlook is the highest point on the Parkway in Virginia. Apple Orchard Mountain is half a mile southwest but can't be seen due to the trees. Instead there is a nice view east to Terrapin Mountain.

✉ **Addr:**	Blue Ridge Pkwy, Bedford VA 24523	♀ **Where:**	37.5214386 -79.5040667
♀ **Milepost:**	76.5	☺ **When:**	Afternoon
👁 **Look:**	East	↔ **Far:**	3.95 km (2.45 miles)

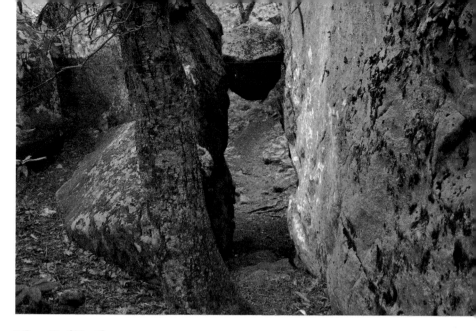

The Guillotine is a large boulder suspended over the Appalachian Trail. Are you brave enough to walk underneath it? Quickly, perhaps.

The hanging rock is about 0.3 miles north of the summit of Apple Orchard Mountain, reached by 110 rock steps built by the local hiking club. At 4225 feet, Apple Orchard Mountain is the highest point of the Blue Ridge Parkway in Virginia, and the most topographically prominent mountain in the state.

✉ **Addr:**	Appalachian Trail, Buchanan VA 24066	♀ **Where:**	37.519329 -79.510195	
♀ **Milepost:**	76.5	☾ **When:**	Afternoon	
👁 **Look:**	North	↔ **Far:**	0 m (0 feet)	

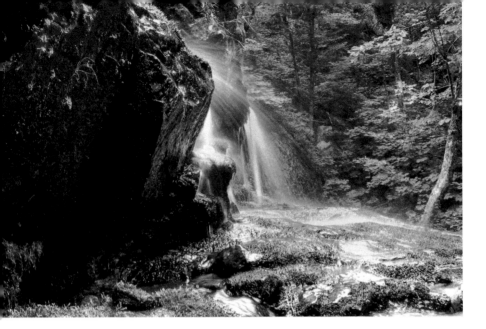

Apple Orchard Falls is a 200-foot-high waterfall with a boardwalk and viewing area.

From Sunset Field Overlook at MP 78.4, hike about 1.5 miles down to the waterfall. The climb back is quite steep.

✉ **Addr:**	Apple Orchard Falls, Buchanan VA 24066	♀ **Where:**	37.516239 -79.532786	
♀ **Milepost:**	78.4 + 1.3	☾ **When:**	Afternoon	
👁 **Look:**	North-northeast	↔ **Far:**	13 m (43 feet)	

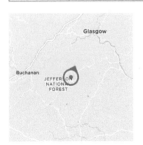

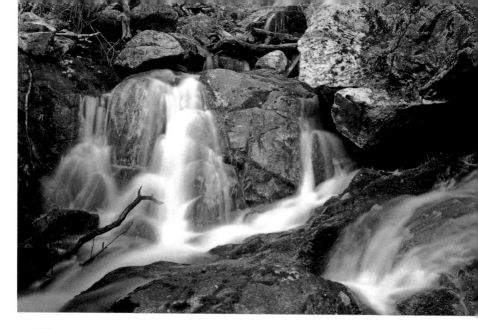

Fallingwater Cascades is a pair of waterfalls where
Fallingwater Creek plummets nearly 100 fee. The lower drop is
approximately 40 feet over a wide rock face.

✉ **Addr:**	Fallingwater Creek, Buchanan VA 24066	♀ **Where:**	37.475086 -79.583116
♀ **Milepost:**	83.1 + 0.7	⏲ **When:**	Afternoon
👁 **Look:**	North	↔ **Far:**	0 m (0 feet)

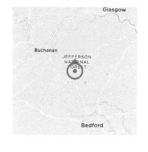

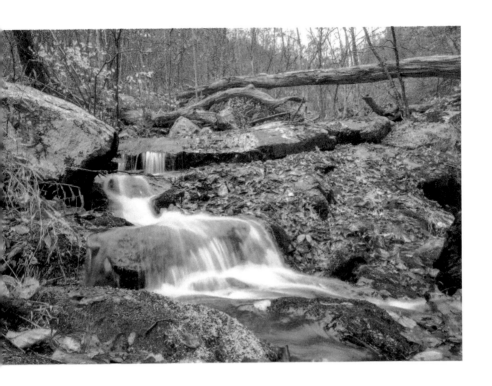

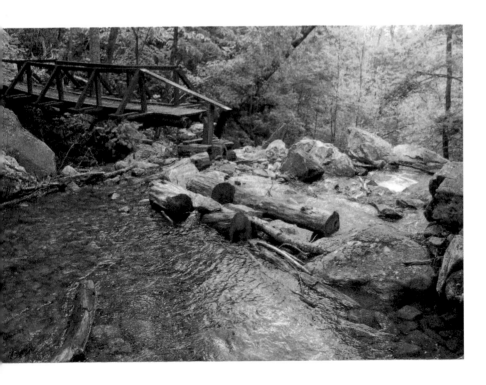

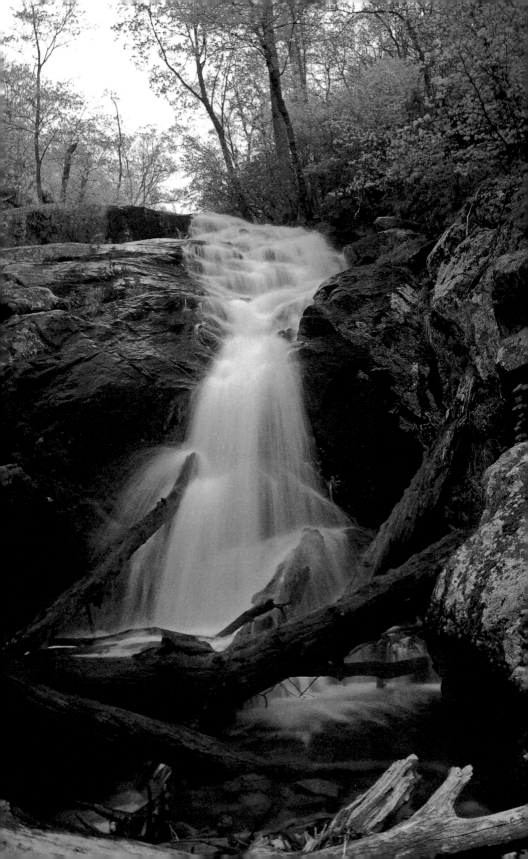

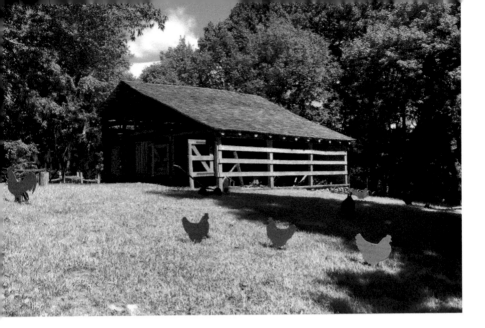

Johnson Farm is the only remaining property from a popular vacation resort that existed here prior to the building of the Blue Ridge Parkway.

Carved from the wilderness in 1767, the farm was bought in 1852 by John Johnson who grew fruit and vegetables for a nearby hotel.

The farm is now a museum and is accessible by trail from the Peaks of Otter Visitor Center.

✉ **Addr:**	Johnson Farm Rd, Buchanan VA 24066	♀ **Where:**	37.455256 -79.604326
♀ **Milepost:**	85.1 + 0.3	◑ **When:**	Afternoon
👁 **Look:**	North-northeast	↔ **Far:**	40 m (120 feet)

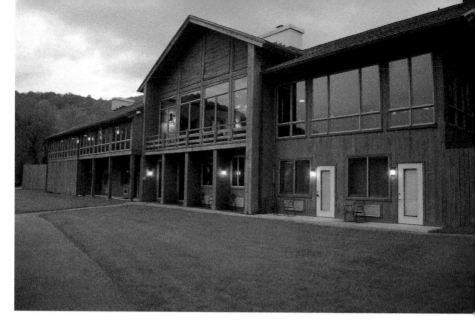

Peaks of Otter Lodge is a 63-room hotel overlooking tranquil Abbott Lake. The hotel and the lake were built in 1964.

The Peaks of Otter are three mountain peaks — Sharp Top (3,875 feet / 1,181 m), Flat Top (4,004 feet / 1,220 m) and Harkening Hill (3,375 feet / 1,029 m).

✉ **Addr:**	85554 Blue Ridge Pkwy, Bedford VA 24523	♀ **Where:**	37.447818 -79.604396
♀ **Milepost:**	85.6	◑ **When:**	Morning
👁 **Look:**	North-northwest	W **Wik:**	Peaks_of_Otter

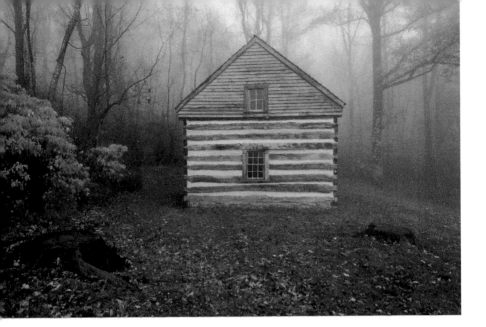

Polly Woods Ordinary is a cabin run in the 1800s by Polly Woods as an "ordinary", a British term for a type of inn, taking care of the "ordinary" needs of travelers.

The cabin is at the east end of Abbot Lake, a pleasant stroll from Peaks of Otter Lodge.

✉ **Addr:**	Johnson Farm Rd, Buchanan VA 24066	♀ **Where:**	37.445123 -79.601892	
♀ **Milepost:**	85.6	☾ **When:**	Afternoon	
👁 **Look:**	East	↔ **Far:**	12 m (39 feet)	

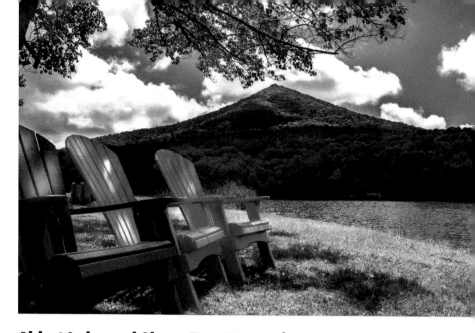

Abbot Lake and Sharp Top Mountain, with inviting chairs at the Peaks of Otter Lodge.

✉ **Addr:**	85554 Blue Ridge Pkwy, Bedford VA 24523	♥ **Where:**	37.446891 -79.604144
♥ **Milepost:**	85.6	☾ **When:**	Morning
👁 **Look:**	South	↔ **Far:**	1.47 km (0.91 miles)

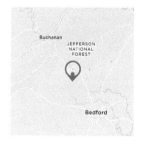
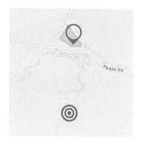

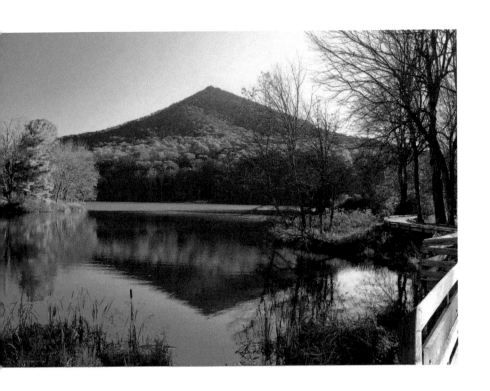

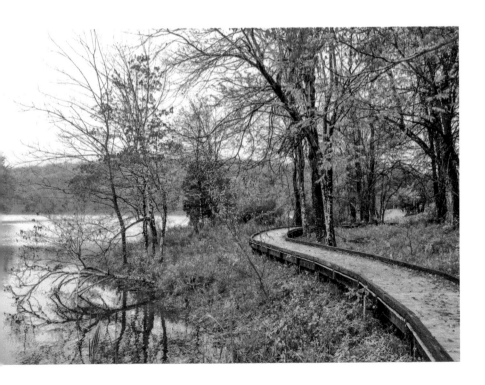

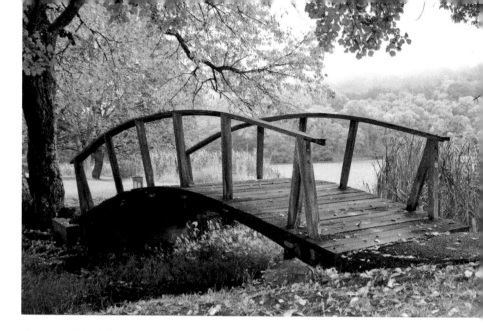

Curved bridge, an arched wooden footbridge at Peaks of Otter Lodge.

✉ **Addr:**	85554 Blue Ridge Pkwy, Bedford VA 24523	♀ **Where:**	37.447195 -79.603911
♀ **Milepost:**	85.6	◑ **When:**	Morning
👁 **Look:**	South-southwest	↔ **Far:**	27 m (89 feet)

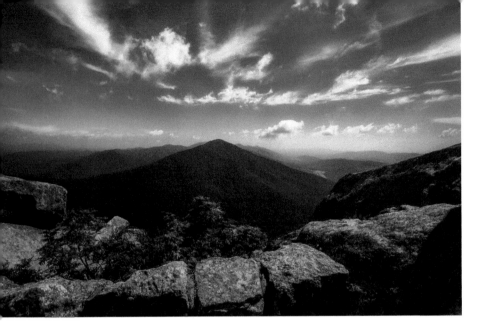

View from Sharp Top Mountain at 3,875 feet. A shuttle from Sharp Top Store takes you to 1,500 feet of the summit, leaving a rocky, rugged, strenuous hike.

The top has a beautiful stone stairway, and a good view back down to Abbot Lake.

Sharp Top Trail is scenic itself.

✉ **Addr:**		♀ **Where:**	37.433592 -79.604969
♀ **Milepost:**	85.8 + 3.4	☽ **When:**	Afternoon
👁 **Look:**	Northeast	↔ **Far:**	0 m (0 feet)

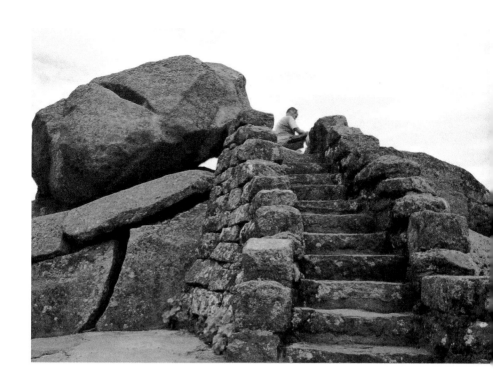

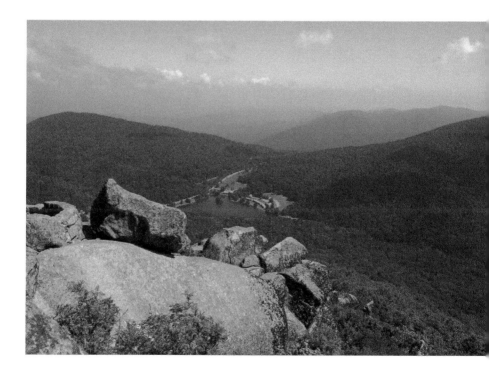

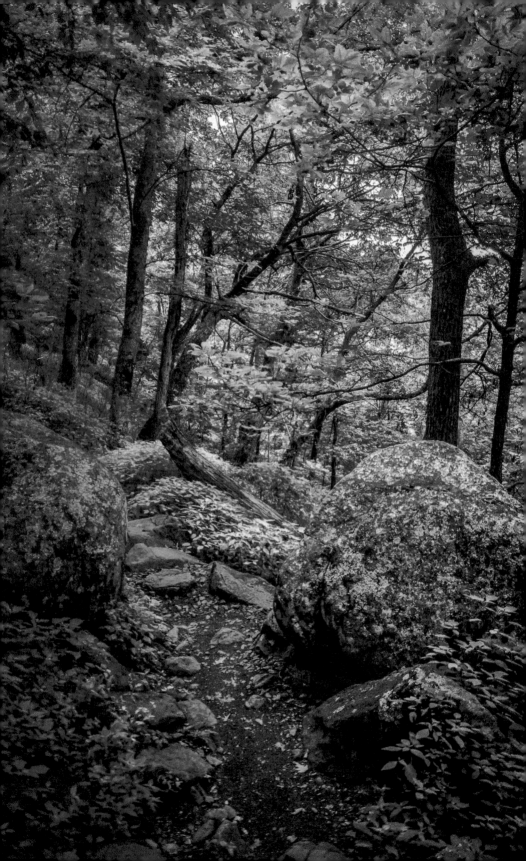

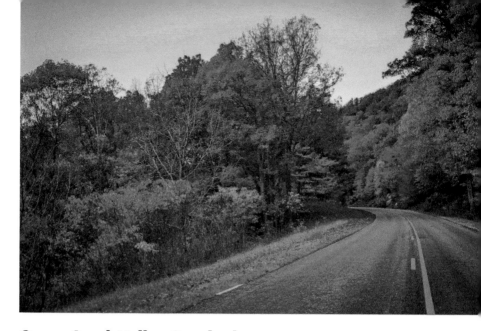

Goose Creek Valley Overlook has nice views of the parkway.

In both directions, is a tree-lined straight road ending with a gentle curve and hills.

✉ **Addr:**	Blue Ridge Pkwy, Montvale VA 24122	♀ **Where:**	37.473898 -79.645349
♀ **Milepost:**	89.4	◑ **When:**	Morning
◉ **Look:**	Northwest	↔ **Far:**	170 m (550 feet)

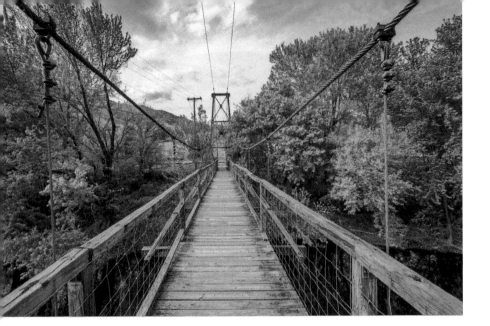

Buchanan Swinging Bridge is a 366-foot-long pedestrian bridge in Buchanan with suspension cables the draw the eye into the picture. Constructed in 1938, the piers of the bridge were built in 1851 for a covered toll bridge.

The bridge crosses the James River in Buchanan, a town part of the Roanoke Metropolitan Statistical Area.

✉ **Addr:**	19908 Main St, Buchanan VA 24066	♀ **Where:**	37.529761 -79.677851
♀ **Milepost:**	90.9 + 4.9	◑ **When:**	Morning
👁 **Look:**	North	W **Wik:**	Buchanan,_Virginia

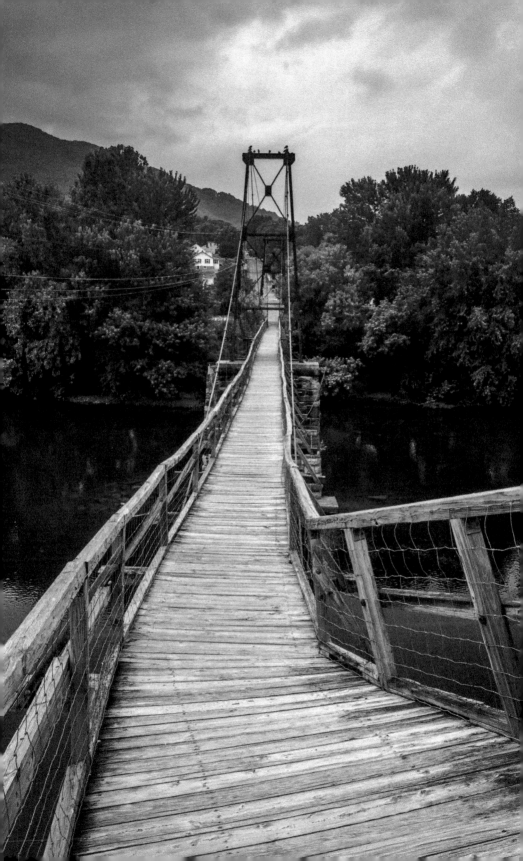

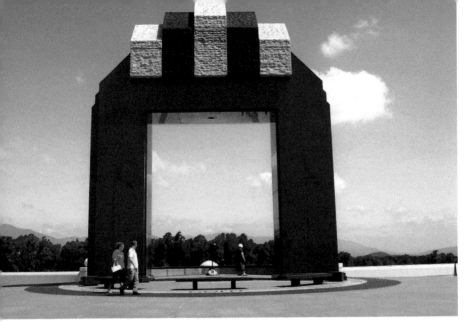

National D-Day Memorial in Bedford opened in 2001 to
commend the Allied Forces during the D-Day invasion of Normandy,
France on June 6, 1944 during World War II.

Of 34 soldiers from Bedford, 23 died in the Normandy campaign,
proportionately the greatest losses of the campaign. They were
chronicled in the best-selling book The Bedford Boys by Alex
Kershaw, which inspired the movie Saving Private Ryan by Steven
Spielberg, who helped fund the memorial.

✉ **Addr:**	3 Overlord Cir, Bedford VA 24523	♥ **Where:**	37.330556 -79.536111
💂 **Milepost:**	101.5 + 20	⏱ **When:**	Afternoon
👁 **Look:**	North	W **Wik:**	National_D-Day_Memorial

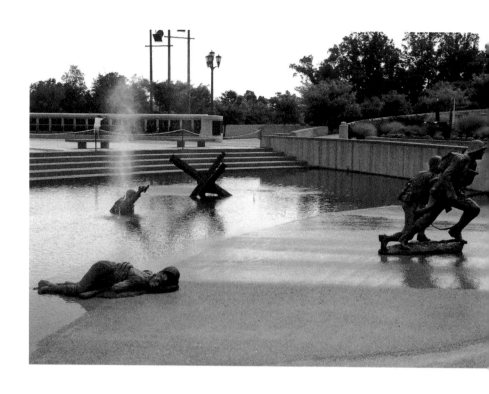

N and W Railroad Overlook views the valley where the line from Lynchburg, VA, to Bristol, TN, was completed in 1856. Following a merger in 1982, The Norfolk & Western Railway is now known as Norfolk Southern.

✉ **Addr:**		♀ **Where:**	37.342061
			-79.844691
♀ **Milepost:**	106.9	☾ **When:**	Afternoon
👁 **Look:**	East	↔ **Far:**	460 m (1520 feet)

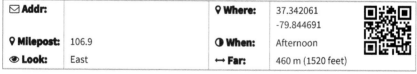

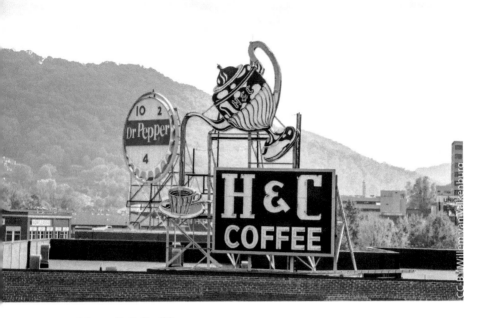

The **H and C Coffee** sign is a landmark in Roanoke. Harold and Clarence Woods founded the company in 1927, and Harold added the neon sign in 1948 on top of the roasting plant on Campbell Avenue Southeast in Roanoke. When the plant was torn down, the sign was moved and now resides by the Taubman Museum of Art.

This view is from the Taubman Museum of Art.

✉ **Addr:**	128 Campbell Ave SE, Roanoke VA 24011	♀ **Where:**	37.272546 -79.937875
♀ **Milepost:**	112.2 + 5.6	◑ **When:**	Afternoon
👁 **Look:**	South	↔ **Far:**	50 m (170 feet)

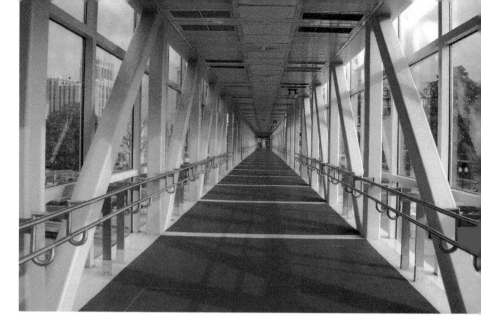

Market Street Walkway is an enclosed pedestrian bridge that crosses the railroad tracks, connecting downtown Roanoke with the Hotel Roanoke.

✉ **Addr:**	Taubman Museum of Art, Downtown Roanoke, Roanoke, 120 Mill Mountain Parkway, Blue Ridge Parkway	📍 **Where:**	37.273239 -79.939367
📍 **Milepost:**	112.2 + 5.6	🕐 **When:**	Morning
👁 **Look:**	North-northwest	↔ **Far:**	30 m (110 feet)

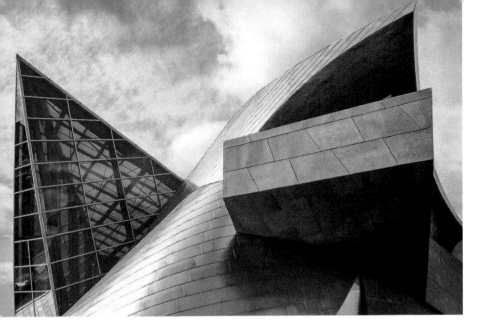

Taubman Museum of Art (formerly the Art Museum of
Western Virginia), is an art museum in Downtown Roanoke,
designed by architect Randall Stout, opened in 2008. named in honor
of lead donor and former CEO of Advance Auto Parts, Nicholas
Taubman.

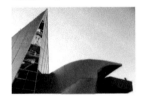

✉ **Addr:**	110 Salem Ave SE, Roanoke VA 24011	♀ **Where:**	37.272977 -79.937698
♀ **Milepost:**	112.2 + 5.6	◕ **When:**	Morning
👁 **Look:**	South-southwest	W **Wik:**	Taubman_Museum_of_Art

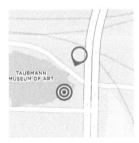

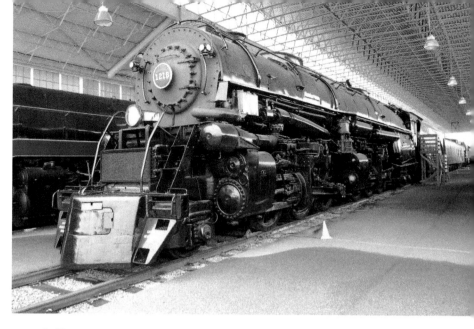

Norfolk & Western 1218 was built in Roanoke in 1943 as the
strongest-pulling operational steam locomotive in the world. No.
1218 is the sole survivor of the Norfolk and Western's class A
locomotives, and the only surviving 2-6-6-4 steam locomotive in the
world.

The train is at the **Virginia Museum of Transportation**, located in
the old Norfolk and Western Railway Freight Station, built in 1918, in
downtown Roanoke.

✉ **Addr:**	303 Norfolk Ave SW, Roanoke VA 24016	♀ **Where:**	37.273193 -79.946300	
♀ **Milepost:**	112.2 + 5.6	☽ **When:**	Afternoon	
👁 **Look:**	North	W **Wik:**	Norfolk_and_Western_1218	

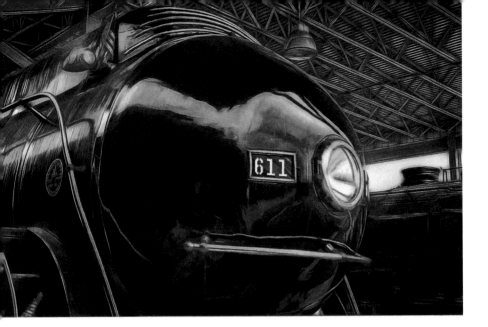

Norfolk and Western J Class 611 is a famous steam train

built in Roanoke. Trains 611-613 were the last steam passenger locomotives built in the United States.

The 611 is a movie star, appearing in a 2016 feature-length documentary called "611: American Icon" which represents the history of the locomotive and her restoration.

✉ **Addr:**	303 Norfolk Ave SW, Roanoke VA 24016	♀ **Where:**	37.273176 -79.946532	
♀ **Milepost:**	112.2 + 5.6	☾ **When:**	Afternoon	
⚉ **Look:**	North	W **Wik:**	Norfolk_and_Western_Railway_class_J_(1941)	

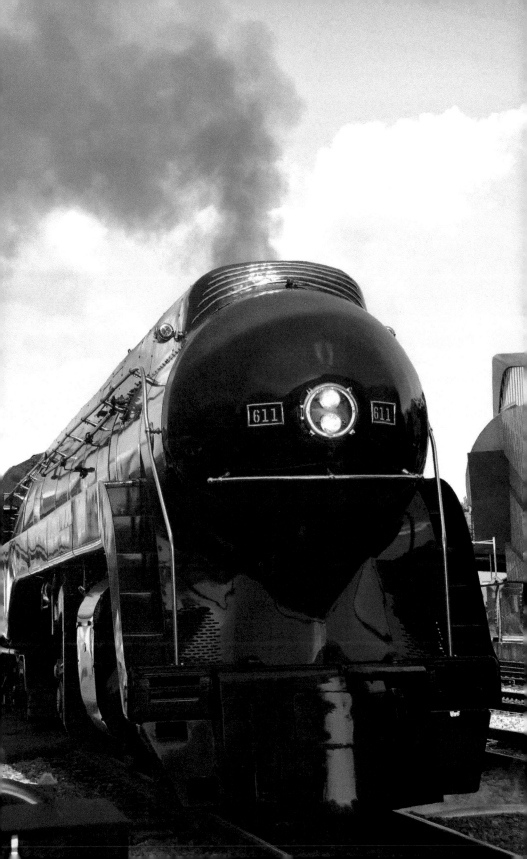

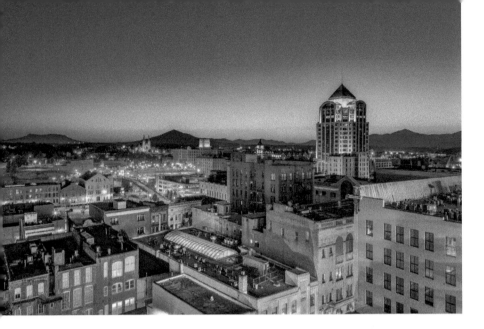

Roanoke skyline from the top of Church Avenue Garage. The tall building is the Wells Fargo Tower in the center of Roanoke.

✉ **Addr:**	121 Church Ave SW, Roanoke VA 24011	♀ **Where:**	37.270888 -79.943408
♀ **Milepost:**	112.2 + 5.6	◑ **When:**	Anytime
👁 **Look:**	Northeast	↔ **Far:**	350 m (1150 feet)

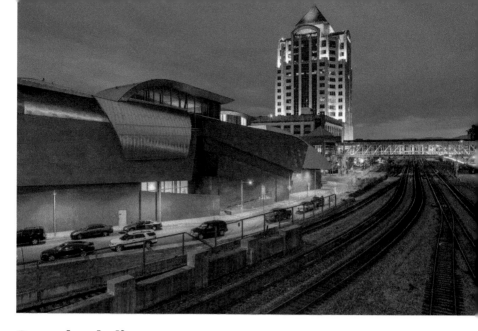

Roanoke skyline from the Williamson Road bridge includes the railroad, Taubman Museum, Market Street Walkway and Wells Fargo Tower.

✉ **Addr:**	Williamson Rd NE, Roanoke VA 24016	♀ **Where:**	37.2733856 -79.9375617	
♀ **Milepost:**	112.2 + 5.6	◑ **When:**	Morning	
◉ **Look:**	West-southwest	↔ **Far:**	240 m (790 feet)	

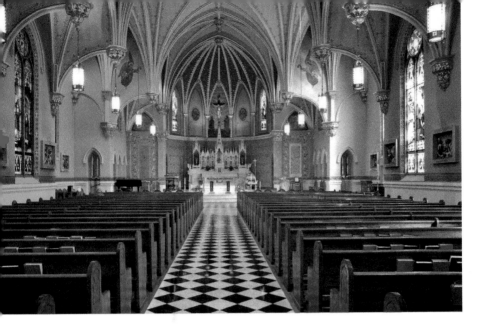

St. Andrew's Roman Catholic Church is an imposing High Victorian Gothic church with two tall towers. Built in 1900–1902 with buff-colored brick, the church is in the Gainsboro neighborhood of Roanoke, north of Downtown.

✉ **Addr:**	631 N Jefferson St, Roanoke VA 24016	♀ **Where:**	37.277801 -79.939828
♀ **Milepost:**	112.2 + 5.6	◑ **When:**	Afternoon
◉ **Look:**	North	W **Wik:**	St__Andrew%27s_Roman_Catholic_Church_(Roanoke,_Virginia)

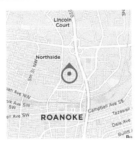

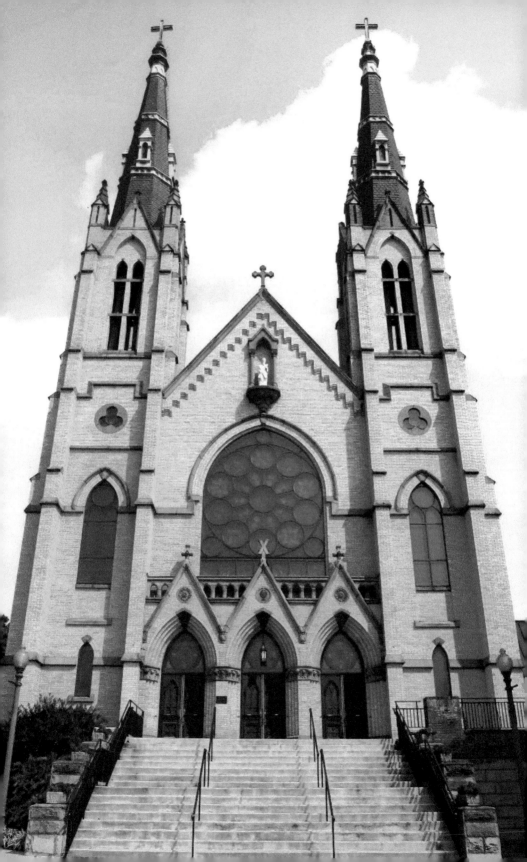

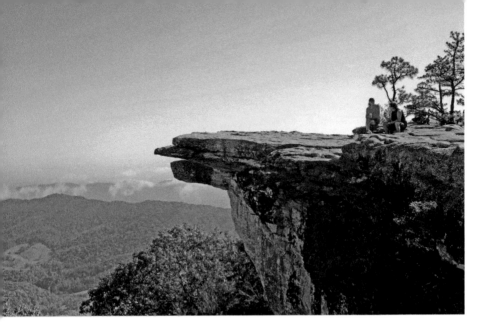

McAfee Knob was named (by the Roanoke Outside Foundation) as the most photographed point along the Appalachian Trail. At an elevation of 3197 feet above sea level, the vista offers panoramic views of the Catawba Valley, 1600 feet below.

The outcrop was featured on the movie poster for A Walk in the Woods, starring Robert Redford, based on travel writer Bill Bryson's 1998 autobiographical book.

It is named for James McAfee (Mac-a-fee), a Scotch-Irish immigrant who settled in the Catawba Valley in the late 1730s.

The hike is a climb of around 1,700 feet and about 4.7 miles to the top of the Knob from the VA311 parking area.

✉ **Addr:**	Appalachian Trail, Troutville VA 24175	♀ **Where:**	37.392466 -80.036274	
♀ **Milepost:**	112.2 + 19.3	☽ **When:**	Afternoon	
👁 **Look:**	North	W **Wik:**	McAfee_Knob	

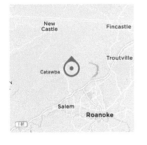

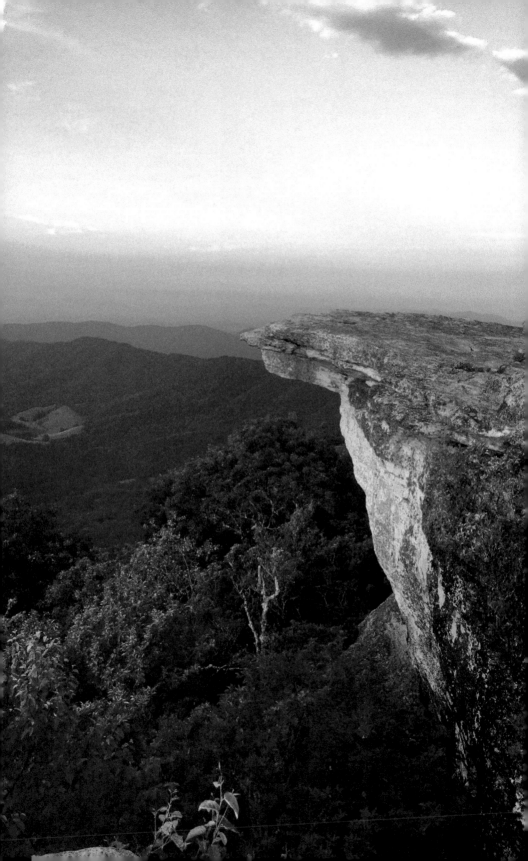

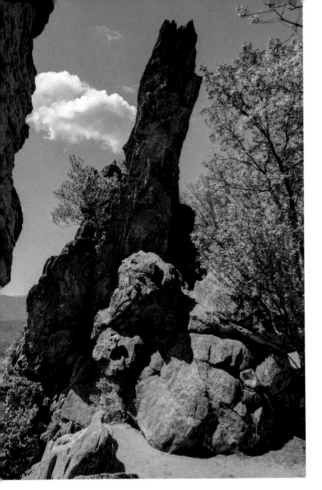

Dragon's Tooth is a 35-foot-high spire of rock, a monolith of Tuscarora quartzite at the top of Cove Mountain, just west of Catawba.

Starts at a parking area off VA311 and follow Dragon's Tooth Trail along the creek. The 2.9-mile-long trail is tough, gaining 1,500 feet in elevation over rock steps.

✉ **Addr:**	Dragons Tooth, Catawba VA 24070	♀ **Where:**	37.360921 -80.173478
♀ **Milepost:**	112.2 + 43.7	☽ **When:**	Afternoon
👁 **Look:**	North	↔ **Far:**	0 m (0 feet)

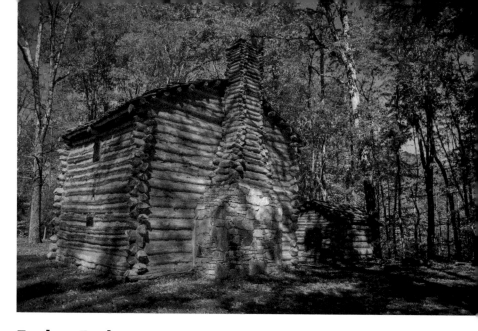

Explore Park is a 1,100-acre (450 ha) recreation facility with various restored local historical structures. Included are: Totero Village, patterned after a Native American village from the late 17th century; Frontier Fort; Leninger Cabin, patterned on a log cabin from the 1750s; Mountain Union Church built in the early 1800s; the 1837 Hofauger House; Slone's Grist Mill, originally built 1880–1890; the working Brugh Tavern; batteau rides to illustrate the flow of commerce prior to the rise of the railroads in the mid-19th century and a common entrepreneurship opportunity for freed slaves.

✉ **Addr:**	56 Roanoke River Pkwy, Roanoke VA 24014	⚲ **Where:**	37.238278 -79.85194	
⚲ **Milepost:**	115.0 + 1.5	⏱ **When:**	Afternoon	
👁 **Look:**	North	W **Wik:**	Explore_Park	

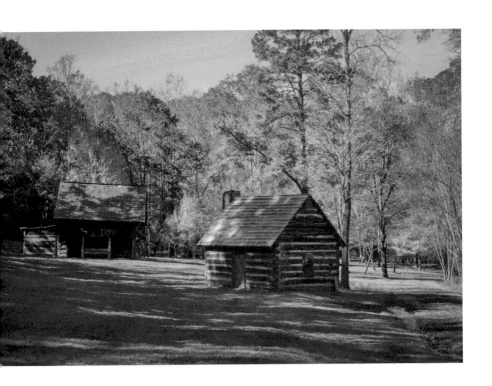

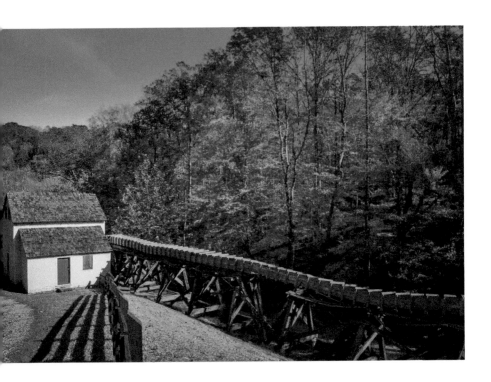

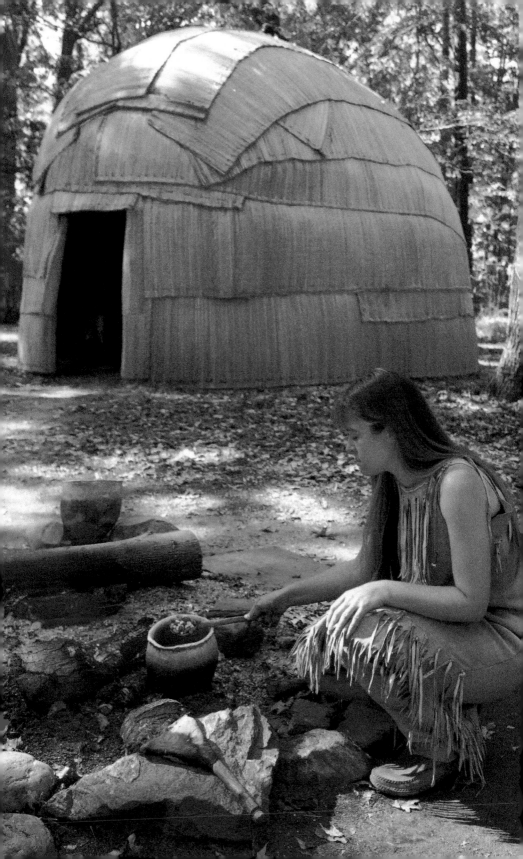

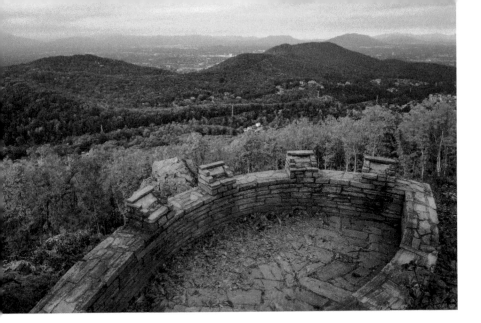

Mill Mountain Overlook on Roanoke Mountain has views of neighboring Mill Mountain, two miles (3.4 km) north, and the city of Roanoke, 3.7 miles (6km) north.

✉ **Addr:**	Roanoke Mountain Rd, Roanoke VA 24014	📍 **Where:**	37.2204103 -79.9386493
📍 **Milepost:**	120 + 1.1	🕐 **When:**	Afternoon
👁 **Look:**	North	↔ **Far:**	3.40 km (2.12 miles)

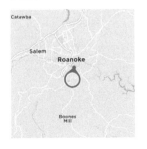

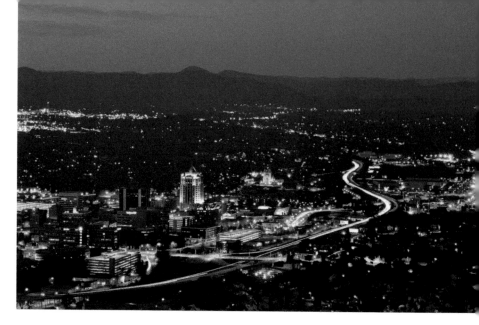

M. Carl Andrews Overlook on Mill Mountain, directly in front of the Roanoke Star, is a viewing platform with a high view of downtown Roanoke, perfect for a dusk shot.

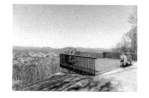

✉ **Addr:**	Watchtower Trail, Roanoke VA 24014	♀ **Where:**	37.251103 -79.932476
♀ **Milepost:**	120 + 3.1	◑ **When:**	Anytime
◉ **Look:**	North-northwest	W **Wik:**	Roanoke_Star#Overlook_and_zoo

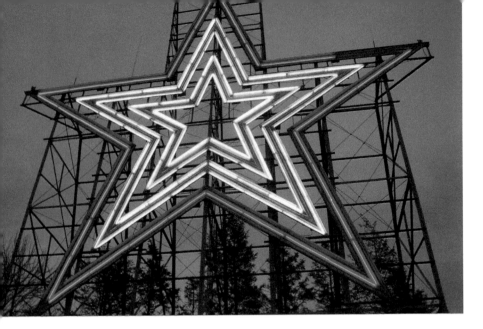

Roanoke Star, also known as the Mill Mountain Star, is the world's largest freestanding illuminated man-made star, constructed in 1949 at the top of Mill Mountain in Roanoke. After construction of the star, Roanoke was nicknamed "Star City of the South." It is visible for 60 miles (97 km) from the air and it sits 1,045 feet (319 m) above the city.

The Mill Mountain Star is 88.5 feet (27.0 m) tall with 2,000 feet of neon tubing which requires 17,500 watts of power to illuminate.

✉ **Addr:**	Watchtower Trail, Roanoke VA 24014	♀ **Where:**	37.251188 -79.932629
♀ **Milepost:**	120 + 3.1	☾ **When:**	Anytime
👁 **Look:**	Southeast	W **Wik:**	Roanoke_Star

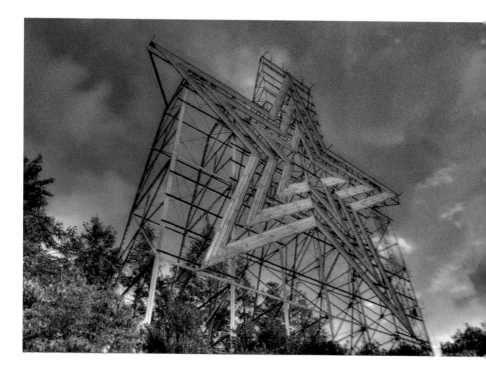

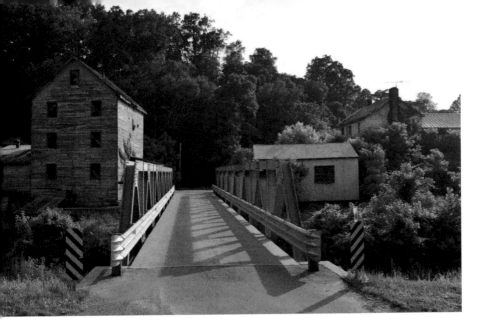

Piedmont Mill is an historic grist mill built in 1866 as the most powerful mill in Franklin County.

✉ **Addr:**	1709 Alean Road, Wirtz VA 24184	♀ **Where:**	37.093637 -79.854185	
♀ **Milepost:**	121.4 + 17.3	☾ **When:**	Morning	
👁 **Look:**	Southwest	W **Wik:**	Piedmont_Mill_Historic_District	

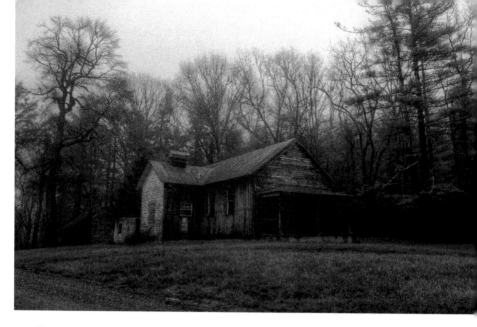

Kelley School is a two-room schoolhouse that was still in operation when the Parkway was built. Founded in 1877 on land purchased from the Kelley family, the current structure was built in 1924 and was also known as Payne's Creek School and Pate/Ware Store.

✉ **Addr:**	680 Kelley School Rd SE, Floyd VA 24091	♀ **Where:**	36.984666 -80.148606
♀ **Milepost:**	149.1 + 0.1	☽ **When:**	Afternoon
👁 **Look:**	East	↔ **Far:**	40 m (120 feet)

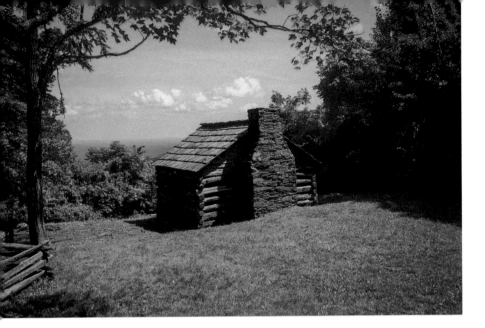

Trails Cabin (also known as Trail Family Cabin and T.T. Cabin)
was built by W. J. Trail in 1890 and stands at Smart View Recreation Area. With a high vantage point, the cabin has "a right smart view" in the namesake vernacular of the region.

The Trail family lived here until 1925 using a nearby spring for water.

✉ Addr:	Smart View Rec. Area, Ferrum VA 24088	♀ Where:	36.927946 −80.186758
♀ Milepost:	154.5 + 0.2	☽ When:	Afternoon
👁 Look:	North	↔ Far:	0 m (0 feet)

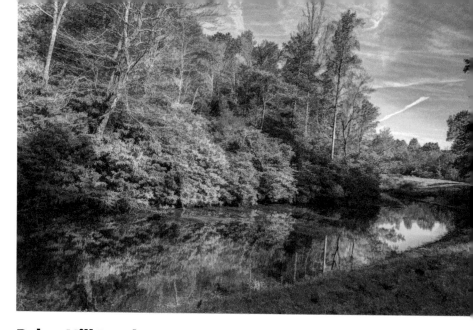

Rakes Mill Pond

Rakes Mill Pond was made by Jarman Rakes in the early 19th century. He allowed his customers sole privilege of fishing for brook trout in his pond while they waited for their grist to be milled. The pond is on Dodd Creek adjacent to the Blue Ridge Parkway.

✉ **Addr:**	Rakes Mill Dam, Floyd VA 24091	♀ **Where:**	36.866064 -80.284647	
♀ **Milepost:**	162.4	◕ **When:**	Afternoon	
👁 **Look:**	North-northeast	↔ **Far:**	80 m (250 feet)	

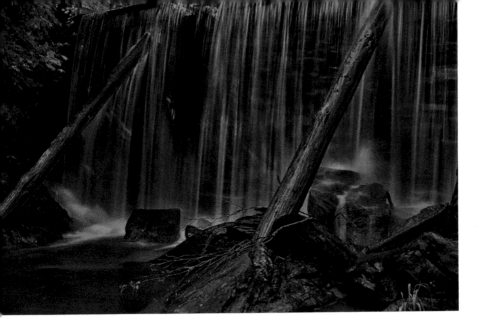

Rakes Mill Pond Dam is probably the nearest waterfall opportunity to the parkway.

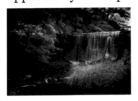

✉ **Addr:**	Rakes Mill Dam, Floyd VA 24091	♀ **Where:**	36.865722 -80.285044
♀ **Milepost:**	162.4	☾ **When:**	Afternoon
👁 **Look:**	North	↔ **Far:**	30 m (100 feet)

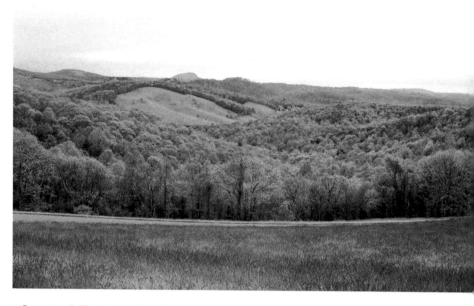

The Saddle Overlook looks east, over Rocky Knob Recreation Area, toward Woolwine.

✉ **Addr:**	Blue Ridge Pkwy, Floyd VA 24091	♀ **Where:**	36.822861 -80.341695
♀ **Milepost:**	168.0	◑ **When:**	Afternoon
👁 **Look:**	East	↔ **Far:**	1.59 km (0.99 miles)

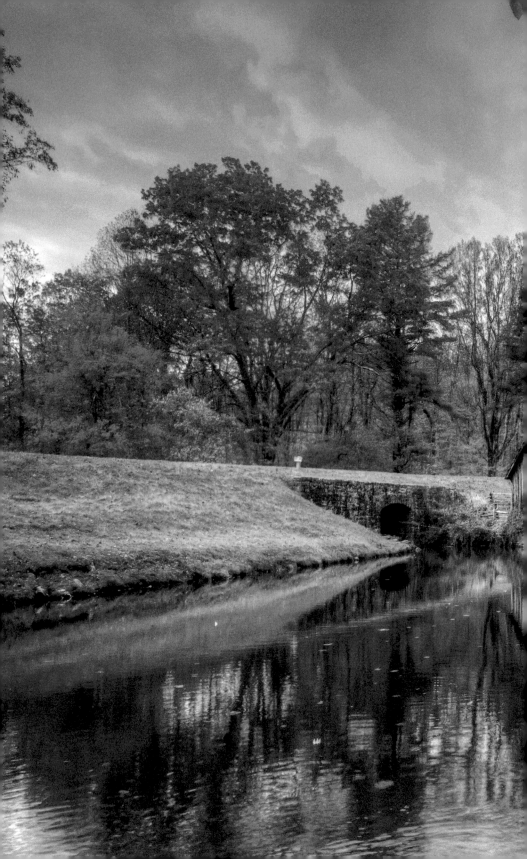

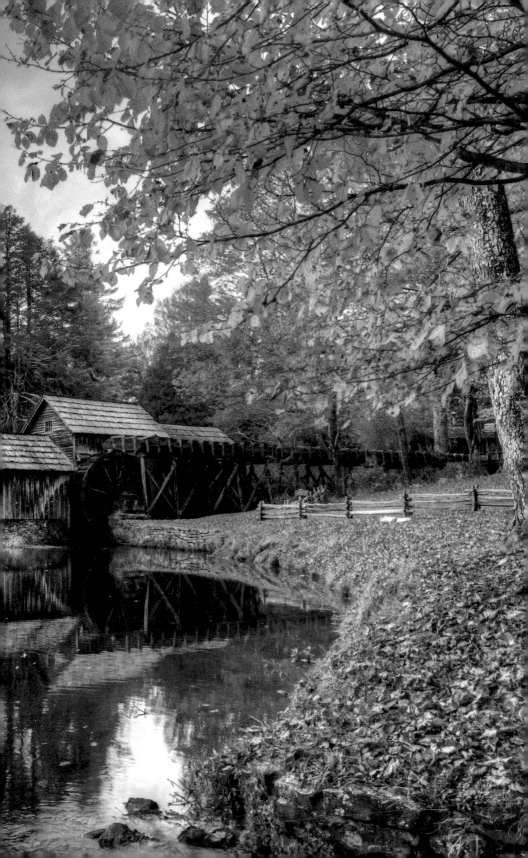

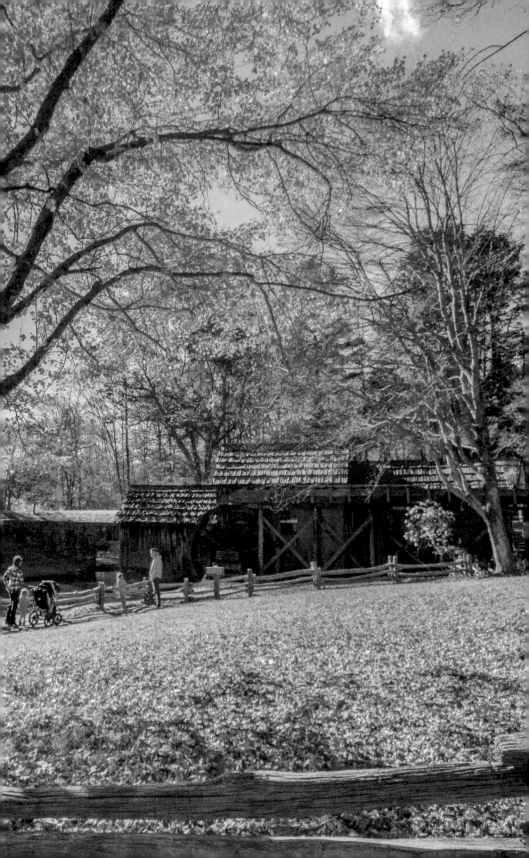

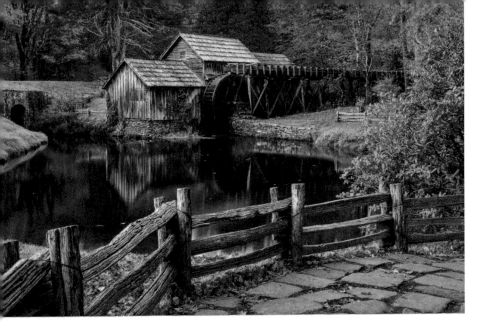

Mabry Mill is a romantic watermill and probably the most photographed sight on the Blue Ridge Parkway. Built by Edwin Boston Mabry in stages from 1903 to 1910, the facility still functions as a sawmill and gristmill. Inside are a lathe for turning out wheel hubs, a tongue and groove lathe, a planer and a jig-saw.

The mill is adjacent to, and can be seen from, the parkway, at milepost 176.2. The Mabry Mill Restaurant and Gift Shop just south has parking and a trail to the classic view, from a viewing area across the pond. The path approaches the water wheel path and winds through the wood along the flume to the north side where there are historic cabins and exhibits.

✉ **Addr:**	266 Mabry Mill Rd SE, Meadows of Dan VA 24120	♀ **Where:**	36.750520 -80.405782
♀ **Milepost:**	176.2	☽ **When:**	Morning
👁 **Look:**	North-northwest	W **Wik:**	Mabry_Mill

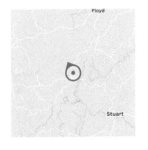
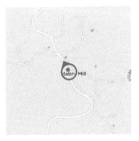

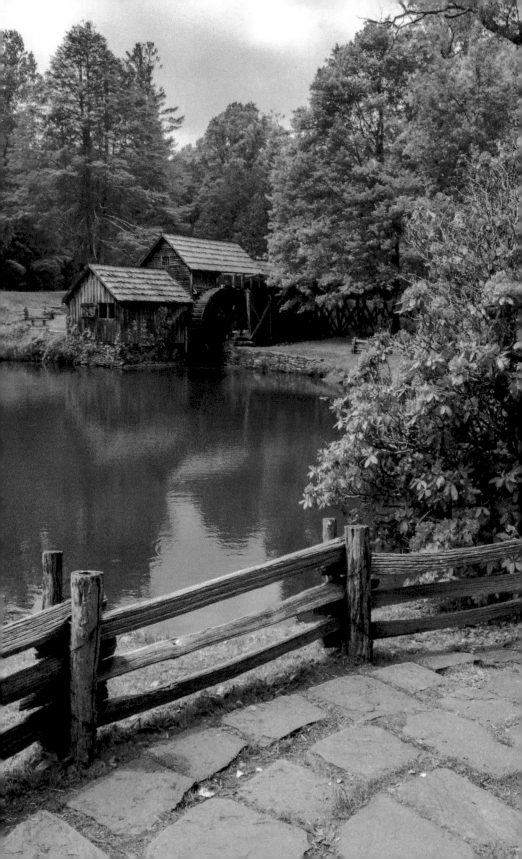

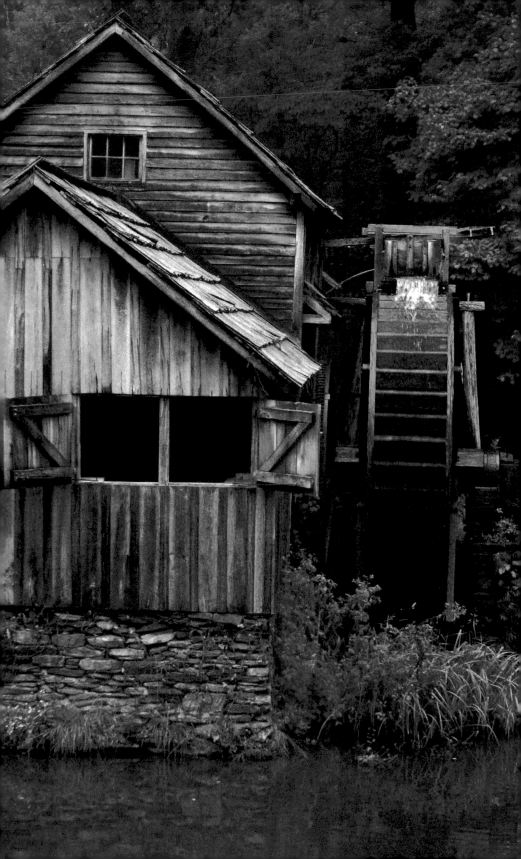

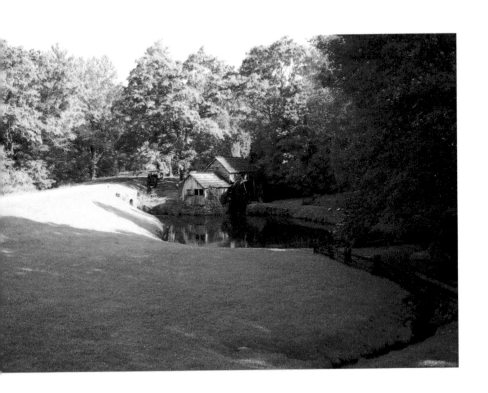

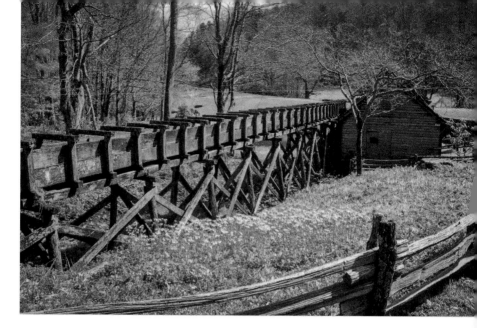

Mabry Mill's **flume** is an elevated wooden channel diverting water to the wheel to provide power. This view is from northeast of the mill.

The flume has several sections, including a passage through the wood with a sluice gate to release water into the pond.

The term flume comes from the Old French word flum, from the Latin flumen, meaning a river. Thought you might want to know that.

✉ **Addr:**	266 Mabry Mill Rd SE, Meadows of Dan VA 24120	♀ **Where:**	36.751099 -80.405887	
♀ **Milepost:**	176.2	☽ **When:**	Afternoon	
◉ **Look:**	South-southeast	W **Wik:**	Flume	

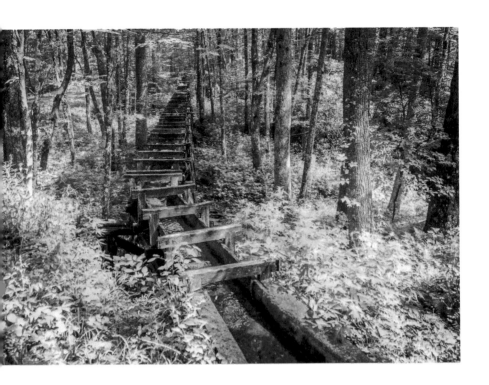

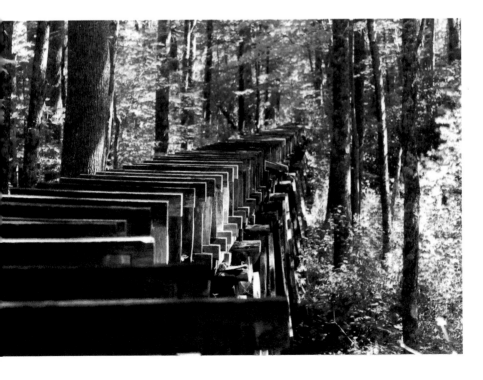

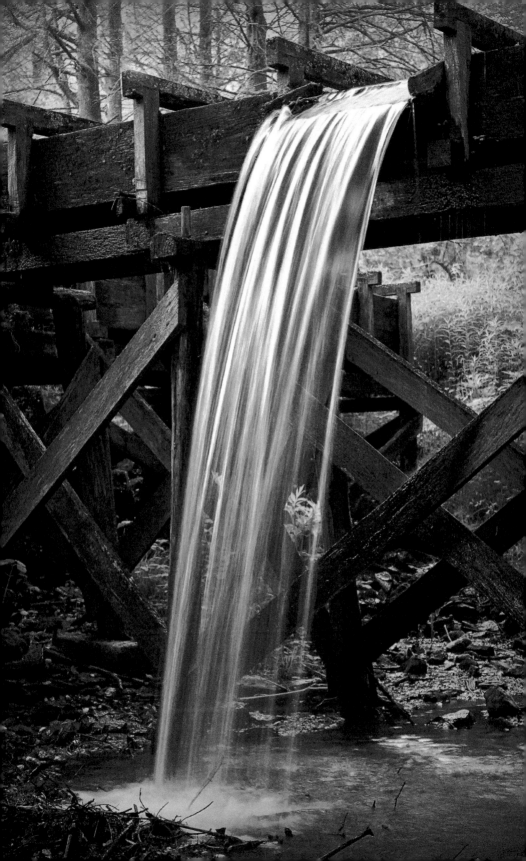

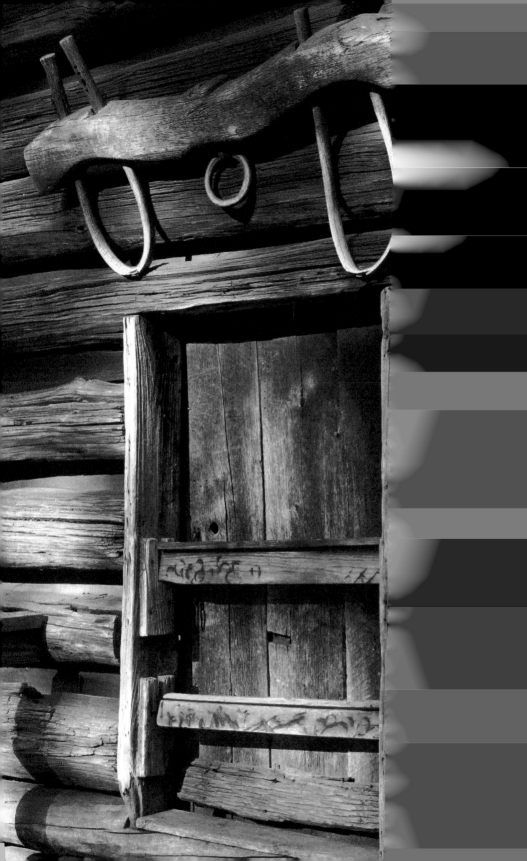

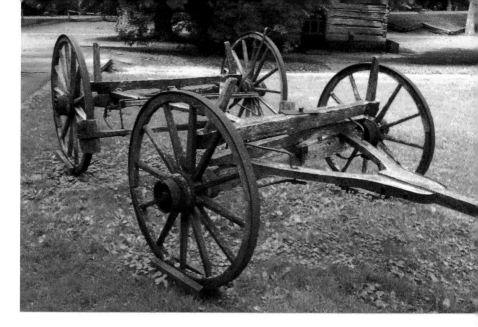

Log cart on the Mountain Industry Trail. A short trail around the mill connects historical exhibits about life in rural Virginia. The **Blacksmith and Wheelwright Shop** (previous page) has period-dressed volunteers during peak seasons.

✉ **Addr:**	266 Mabry Mill Rd SE, Meadows of Dan VA 24120	♀ **Where:**	36.751172 -80.406165
♀ **Milepost:**	176.2	◐ **When:**	Afternoon
👁 **Look:**	North	↔ **Far:**	0 m (0 feet)

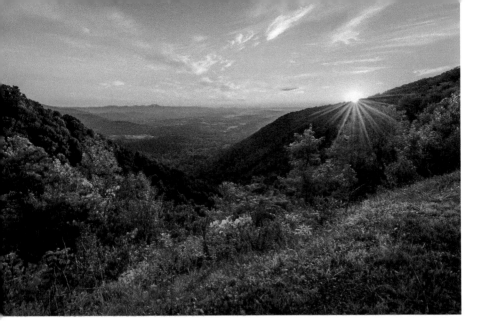

Lovers Leap Overlook is reputedly named for the son of a settler and the daughter of an Native American chief.

✉ Addr:	Jeb Stuart Hwy, Stuart VA 24171	♀ Where:	36.717832 -80.324892
♀ Milepost:	177.7 + 6.5	☽ When:	Sunrise
👁 Look:	East-northeast	↔ Far:	0.69 km (0.43 miles)

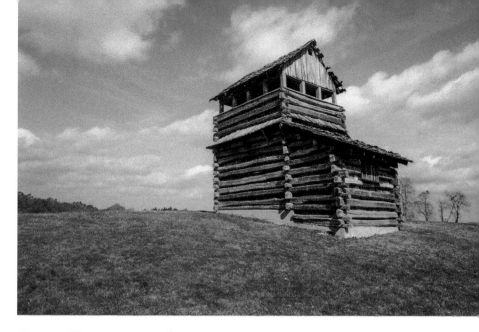

Groundhog Mountain Tower is a 20-foot-high fire lookout built in 1935 to look like an old tobacco barn. The elevation is 3,044 ft (928 m).

✉ **Addr:**	500 Groundhog Hill Rd, Ararat VA 24053	♀ **Where:**	36.633597 -80.537235
♀ **Milepost:**	188.9 + 1.0	☽ **When:**	Afternoon
👁 **Look:**	North	↔ **Far:**	0 m (0 feet)

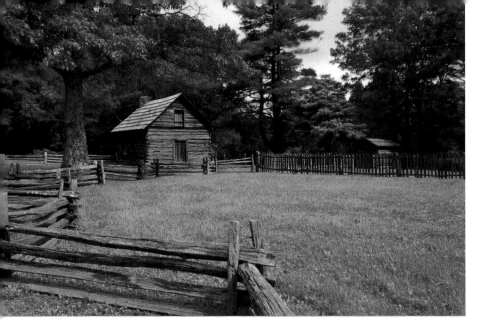

Puckett Cabin is a tiny one-room wood cabin hardly larger than an average dining room, the last home of Orleana Hawks Puckett, a mountain-based midwife from 1889 until 1938. Although never documented, it is said she helped deliver more than 1,000 babies, and never lost a mother or a child. In 2012, Puckett was posthumously honored as one of the Library of Virginia's "Virginia Women in History."

She started being a midwife after she herself had lost 24 children, possibly due to a blood disease. She was almost 50 years old when she started her "practice", on a completely voluntarily basis.

✉ **Addr:**	Blue Ridge Pkwy, Hillsville VA 24343	♀ **Where:**	36.643269 -80.547633
♀ **Milepost:**	189.9	☽ **When:**	Afternoon
👁 **Look:**	East-southeast	W **Wik:**	Orelena_Hawks_Puckett

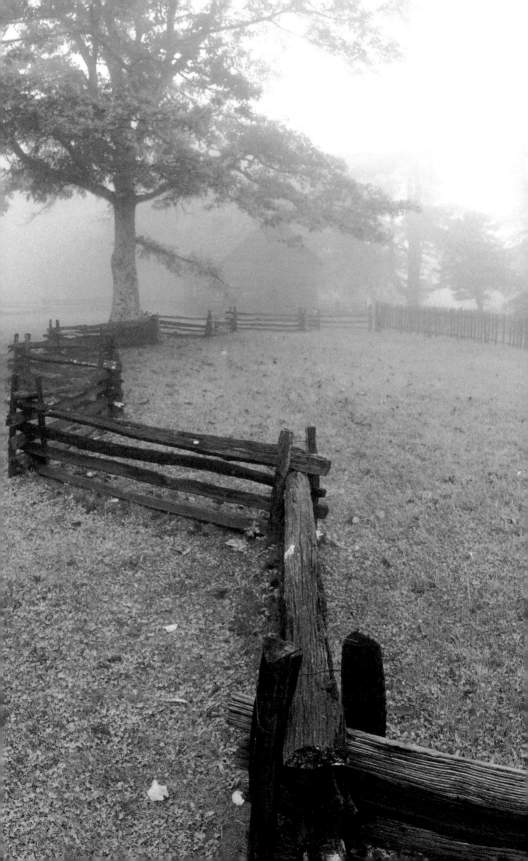

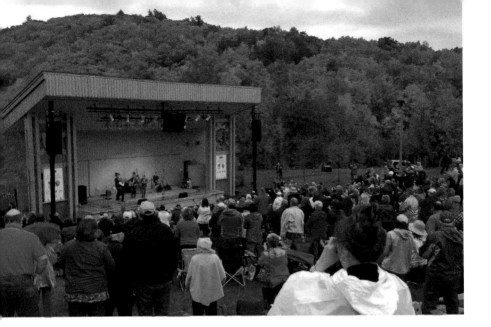

Blue Ridge Music Center is a music venue, museum, and visitor center located at milepost 213 on the Blue Ridge Parkway near Galax, Virginia. The center celebrates the music and musicians of the Blue Ridge Mountains through concerts, exhibits, and programs, and is operated through a partnership between the National Park Service and Blue Ridge Parkway Foundation.

✉ **Addr:**	700 Foothills Rd, Galax VA 24333	♀ **Where:**	36.573442 -80.851568
♀ **Milepost:**	213.0 + 0.4	☽ **When:**	Afternoon
👁 **Look:**	South-southeast	W **Wik:**	Blue_Ridge_Music_Center

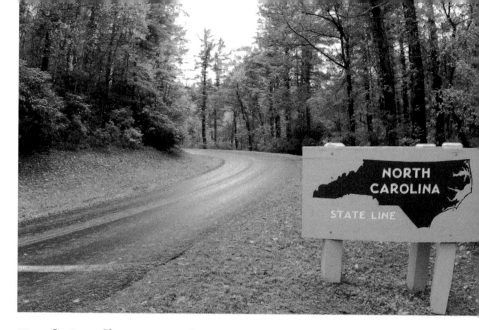

North Carolina State Line at MP 217 marks almost the half-way point of the 469 mile (755 km) Blue Ridge Parkway. You're leaving the "Old Dominion" state of Virginia for the Old North State of North Carolina.

✉ **Addr:**	Blue Ridge Pkwy, Galax VA 24333	♀ **Where:**	36.562298 -80.912322
♀ **Milepost:**	216.9	◑ **When:**	Morning
👁 **Look:**	Southwest	↔ **Far:**	40 m (120 feet)

QR codes

Each location includes a QR code which you can scan to show the GPS spot on your smartphone.

A QR code (for **Quick Response** code) is a two-dimensional barcode which stores text — in our case, GPS coordinates. When scanned, the data will be recognized as a location and be passed to a map app. Typically, the map will center on this spot and highlight it with a marker.

Using a QR code is like taking a photo — just point and shoot. Then tap to see the location on your map app.

How to use QR codes

1. ⮌ **Get an app**
 You may need an app to scan a QR code. There are many free apps; search for "QR reader". I like **QR Code Reader** and **Quick Scan** (both are free).

2. ⮌ **Scan the QR code**
 Point your smartphone's camera at the QR code. When the camera has the QR code in focus, the app will automatically scan it.

3. ⮌ **Tap to map**
 Depending on the app, you will either be taken immediately to your map app, or be given an option to do so. (Note: GPS locations are approximate so use prudence.)

 # Credits

Thank you to the many wonderful people and companies that made their work available to use in this guide.

Photo key: The number is the page number. The letters reference the position on the page, the distributor and the license. Key: a:CC-BY-SA; b:bottom; c:center; d:CC-BY-ND; e:CC-PD; f:Flickr; h:Shutterstock standard license; l:public domain; s:Shutterstock; t:top; w:Wikipedia; y:CC-BY.

Cover image by Larry Knupp/Shutterstock. Back cover image by Jim Lukach/Flickr. Antepenultimate (55t fy); Taber Andrew Bain (77t sh); Jon Beard (90t sh); Jon Bilous (25t, 41b, 52, 96t, 104t, 104, 105, 117t sh); Kristi Blokhin (127 fe); Blueridgeparkway Nps (31t, 34c, 35c, 46t, 56t, 59t, 61t, 84t, 85t, 88t, 89t fy); Bobistraveling (36, 82t, 82, 83, 84 sh); Steve Bower (150 sh); Richard L. Bowman (99 sh); Paul Brady Photography (42t sh); Spencer D Casteel (97t fy); Charlie (66 sh); John M. Chase (23t fy); Eli Christman (38 fy); Rusty Clark (29 fy); Ryan Crierie (107b, 108 fy); Daveynin (109t, 154, 155, 157t fd); David (112, 119 fd); Chris Dilworth (73, 76t, 76 fa); Dlhdavidlh (144t fd); Dougprowse (113t wa); Famartin (30t, 38t, 39t, 47, 49t sh); Darren K. Fisher (129t wa); Fopseh (26b, 27 sh); Zack Frank (68, 142 sh); Thomas Gari (57, 59 sh); Cindy Goff (29t sh); Angelo Hannes (122t sh); Anthony Heflin (140t wl); Carol Highsmith (125 fa); Todd Van Hoosear (62t, 83t, 95t sh); Hsa Htaw (36t wa); Idawriter (45t, 45b, 48t, 135t sh); Irinak (42, 43 fy); James St. John (73t wy); Charlie Johnson (66t sh); Jomo333 (58t, 80t, 80 sh); Kelleher Photography (41t sh); Marcela Kirk (147 sh); Larry Knupp (136 fa); Sarath Kuchi (138 sh); Laheishmanphotography (99t sh); Galleria Laureata (64t fd); Letscounttheways (78t, 79 fy); Jim Lukach (33, 100t sh); Jon Marc Lyttle (28, 86t, 87t, 95, 96, 98b, 102, 103t, 123t, 124t, 124b, 132t, 145t, 146t wa); Laura Macaluso (94t sh); Rui Serra Maia (120t sh); The Old Major (101t, 106t, 107t, 115 sh); Marner3 (121 fy); Richard Martin (101b sh); Dustin Mccollum (111t fd); Amy Meredith (74t, 75t, 75b wa); Minweb (128t fy); Patrick Mueller (46, 92b wa); Nationalparks (32t sh); Normphoto (50t fy); Donnie Nunley (114t, 131t, 133t, 148 wl); Nyttend (60t, 130t sh); Outdoorimages (98t fy); Virginia State Parks (67t, 69t, 71t, 72t, 72 sh); Sean Pavone (116t fy); Ted Van Pelt (134t, 134 fy); Pixydust8605 (37t wl); Pubdog (63t sh); Joe Ravi (118t, 127t sh); Nicolas Raymond (56 sh); Bram Reusen (40t, 44t, 92t, 126t, 153t wy); Morgan Riley (53t, 54t sh); O.c Ritz (112t wa); Rmlark (156t sh); Justin M Saunders (81 sh); Scottymanphoto (152t sh); Seancwilliams (51 fe); Jeff Sharp (47t sh); Sjarrell (154t fy); Soupstance (24 sh); Thebigmk (91t, 93 sh); Thomason Photography (129b fy); Danny Thompson (144b, 151t wl); Stained Glass Artist Is Unknown (26t fy); Willem Van Valkenburg (71, 110t wy); Vastateparksstaff (70t sh); Katherine Welles (65 sh); J.k. York (143 fy); Zenjazzygeek (146b fy).

Some text adapted from Wikipedia and its contributors, used and modified under Creative Commons Attribution-ShareAlike (CC-BY-SA) license. Map data from OpenStreetMap and its contributors, used under the Open Data Commons Open Database License (ODbL).

For corrections and improvements, thank you to these local leaders: Karen Searle at Eastern National; National Park Service; Blue Ridge Parkway Association.

This book would not exist without the love and contribution of my wonderful wife, Jennie. Thank you for all your ideas, support and sacrifice to make this a reality. Hello to our terrific

kids, Redford and Roxy.

Thanks to the many people who have helped PhotoSecrets along the way, including: Bob Krist, who answered a cold call and wrote the perfect foreword before, with his wife Peggy, becoming good friends; Barry Kohn, my tax accountant; SM Jang and Jay Koo at Doosan, my first printer; Greg Lee at Imago, printer of my coffe-table books; contributors to PHP, WordPress and Stack Exchange; mentors at SCORE San Diego; Janara Bahramzi at USE Credit Union; family and friends in Redditch, Cornwall, Oxford, Bristol, Coventry, Manchester, London, Philadelphia and San Diego.

Thanks to everyone at distributor National Book Network (NBN) for always being enthusiastic, encouraging and professional, including: Jason Brockwell (who suggested Lisbon), Jed Lyons, Kalen Landow (marketing guru), Spencer Gale (sales king), Vicki Funk, Karen Mattscheck, Kathy Stine, Mary Lou Black, Omuni Barnes, Ed Lyons, Sheila Burnett, Max Phelps, Les Petriw and Amy Alexander. A special remembrance thanks to Miriam Bass who took the time to visit and sign me to NBN mainly on belief.

The biggest credit goes to you, the reader. Thank you for (hopefully) buying this book and allowing me to do this fun work. I hope you take lots of great photos!

Index

☺ About PhotoSecrets

👍 Founded in 1995.
👍 First color travel photo guides (1997).
👍 18 color photography books published.

Coming soon:

Also available: